cottages on the coast

LINDA LEIGH PAUL

cottages
on the coast

fair harbors and secret shores

UNIVERSE

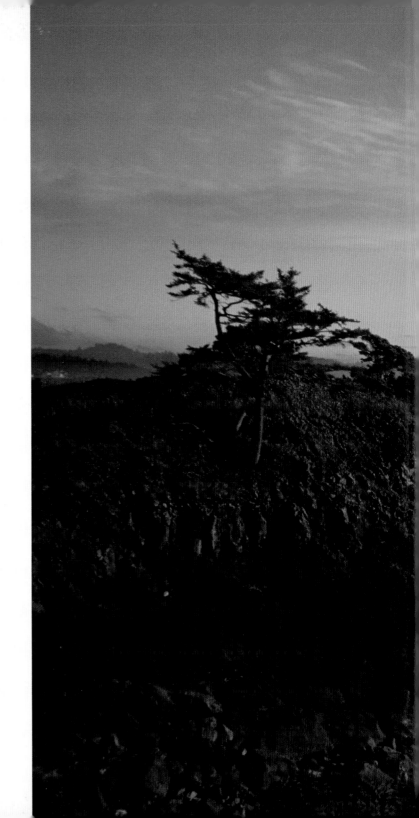

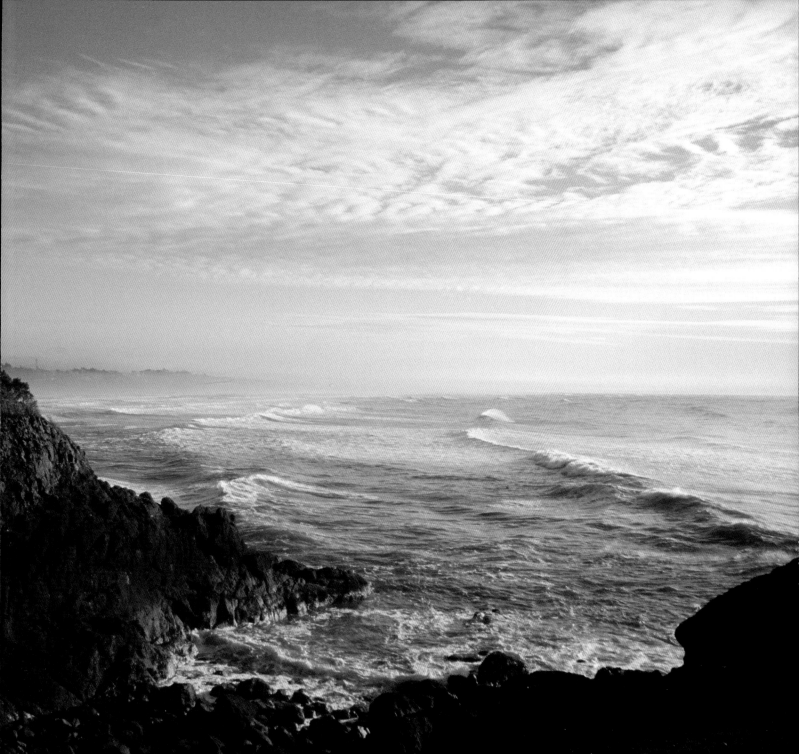

ADDITIONAL PHOTOGRAPHY CREDITS:

Amory Architects: 67

Computer Lab: Ketchum, Idaho, 1989, "Tennessee Williams in Key West and Miami": 19 (left and right)

Corbis: 2–3, 8, 11, 13, 15, 222

DiMaio, John: 161

Forman, H.C. : 16 (right)

Henderson, Dick and Delaine: 18 (upper and lower)

Henry E. Hunington Library and Art Gallery: 107

Jensen, Mike: 21

Johnson, Richard Leo : 4

Library of Congress: 17 (upper left and right)

Mathers, Michael: 5, 6, 7, 143, 148, 149 (left and right), 213, 224

Nantucket Historical Society: 16 (upper left)

Private Collection, Anonymous, 17

Tybee Historical Society: 16 (lower left and right)

Wadsworth, John: 64

First published in the United States of America in 2003
by UNIVERSE PUBLISHING
A Division of Rizzoli International Publications, Inc.
300 Park Avenue South
New York, NY 10010
www.rizzoliusa.com

Design by Tom Whitridge/Ink, Inc.

2007 /
10 9 8 7 6 5 4

Printed in China

ISBN-13: 978-0-7893-1070-5

Library of Congress Catalog Control Number: 2004101643

Contents

Island life is for special friends.

Window wonderland;
the flowers and the sea

Introduction

. . . the slow float of differing light and deep . . .

Ezra Pound . . . *Portrait d'une Femme*

THE SEASIDE COTTAGE is an inscrutable berth. The little dwellings adhere to the earth, braced against heavy seas, swelling tides, and unpredictable weather. Each small house is an emblem of the kind of simple courage one must have and of the passion one must bring to live in it. And, like the cottages, navigational charts are as much maps of the psyche as they are of the courses around headlands, capes, and shoals; through straits; and into bays and harbors. The building and naming of such craggy and difficult places draws on emotions shaped by many departures and returns, the mastery of finding shelter and safety, and the thrill of escaping danger. Fearsome names—Destruction Island, Peril Strait, Wrath Cape—denote the arcs of shorelines. Cape Disappointment preserves the sentiment of the Corps at the end of Lewis and Clark's long journey of discovery. Yet other coastlines offer Fair Harbor, Port Protection, or Safety Harbor. And there are those that hint at spirited encounters: Dogs Keys Pass, Tortugas Harbor, and Alligator Reef.

The shoreline reveals its mysteries to those who are willing to live and spend time there, drawn to the soul-challenging, soul-refreshing sea. What can be learned from the ocean? And more important, how can one learn it? An old house high on a bluff road is a telescopic pinpoint—a landmark—from the crest of an ocean swell far out at sea. It

might be the cottage where a friend's aunt has lived for most of her eighty years. Her furnishings are the vestiges of the many lives that are her lifetime—journals, letters, postcards, books, the remaining bed of a set of two, a silk pillow. She is a bit of a collector and surrounds herself with anything written; and her collections speak of what she has learned from the sea itself. For a woman of the sea, it is said that a day spent near the sound of the waves is a lifetime. The ocean is a vast emotional heartland—its sorcery makes it one of the great touchstones of human passion and inspiration; there they are born and there they endlessly return. Passions are born in the deep, yet they are aroused by the smallest of impulses and impressions. Just as diminutive ripples on the surface of the ocean are driven over its surface by the wind to emerge as enormous waves, so do emotions and passions grow, swell and return:

> *These tiny ripples . . . snag more of the winds energy and ripen into wind chop, which if augmented by fresh agitation, assumes a confused, irregular pattern called a sea. How high the waves will eventually develop depends on the fetch, the distance the waves can run without meeting an obstacle . . . which is why really big waves cannot be produced in the confines of a bay. As soon as waves move beyond the reach of a driving wind, they lose their peaked shape and become swell—long low and rounded. Swell moves swiftly through the ocean for thousands of miles until it becomes a breaker, as it approaches the shore.*[1]

Ocean swells move rapidly, change in form and force, until once again, they break upon the shore. Their movement resembles the mysterious paths of human passion. How can the sorcery of the sea be illuminated by passion? Is it more than the wind over the water? More than the vastness of which the poets (and even philosophers) sing? Is it the return of the waves to the shore? Can it be folklore, such as this passionate story of *Freyja*:

> *the Norse goddess of love and fertility, who could turn herself into a falcon and fly for a day and a night over the sea; who could shepherd the fish into the nets of the fishermen; who could happily sleep with an entire family of elves, each one of which would present her with a link in an*

amber necklace after the night she had given him. One shape Freyja
would never adopt was the chaste and abstinent virgin. She was always
fully engaged with life, ripe in body and desire.[2]

Emotions cause the spirit of the individual to quicken: love, fear, poetic memory. Perceptions of the sea, of course, mingle with expectation, and soon events enter the realm of Proustian sensibility: the smell of the ocean air, seaweed drying on driftwood, wood smoke blowing over the sand—bring back suddenly the elation of a special moment. We may believe, innocently, that we are lured to the beach by a need for "a vacation." It is surprising then, to learn that we are lured by a far greater need: a *prima materia*. It is more than the salt air, sea breezes, or wood smoke; our "souls" are drawn to the ocean by more than a thought: we are drawn to it in the way wild salmon are drawn to return to their spawning grounds—by a sensual and delicious smell. The seasonal growth and death of billions of microscopic surface phytoplankton—plant-like creatures—creates the sensual and delicious smell. It is a chemical beckoning of the kind we get when peaches and apples ripen, a signal telling us when something is ready to eat. Not only does the dimethyl sulfide (DMS) attract us to the water, but at certain times of the year it makes us very hungry. It would be hard to stay away if we wanted to. The chemical released into the air when at a certain strength, attracts us to it!

Of course, it may not be the dimethyl sulfide at all. It could be sounds, the sounds of the sea: *I hear the mermaids singing each to each . . .*, that capture our spirit and lure us to the water. Adam Nicolson writes of the Sound of the Shiant—a strait between a small grouping of three islands named the Shiants (Shants) and their headlands. Between them is the Minch, a body of rough water which is protected by the Stream of the Blue Men, or more precisely, the Blue-Green Men, reflecting a color of the sea and the base of a dark cliff. Nicolson describes the Blue Men as:

. . . strange dripping, semi-human creatures who come aboard and sit
alongside you in the sternsheets, sing a verse or two of a complex song and,

if you are unable to continue in the same metre and with the same rhyme,
sink your boat and drown your crew.[3]

Legends of scuttled creatures and sea monsters were invented to keep timid people on the shore. Fear and awe of the great waters, those bleak and hostile regions notorious for their unpredictability, ruled people for centuries. Close to the sea however, it is hard to resist the release and freedom that that nearness offers, as it heightens our enthusiasm and our knowledge of our own being—paradoxically, the fearsome sea can teach us to conquer our fears. When the waters were finally challenged, and bathing became an instant cure for nearly every ill, even the beauty of some women was attributed to the fact that they could swim. Perhaps, it is just the magic. The spellbinding glitter in flecks of light moving under dark clear summer waters, underwater fairies—so close, so elusive, so alive. What happened when we learned that these were single-celled plankton, the phosphorescent shivers of light-giving *Phosphoros*: That their flashes of light are signals of their own sensitivity and fear? Is knowledge possible by just seeing or smelling? Can we learn about our world from the adrenaline rush that comes from watching rhythmic huge waves tear and chisel the edges out of stone bluffs? Does it make us realize that the shape of a cliff is the result of the mute resistance to the forces breaking against it? The forces and the passions?

That knowledge can be gained from emotions—passion, love, fear—and memories tied to sensory perceptions, however, is rejected by the traditions of philosophy. The idea seems frivolous. Yet, can *you* imagine having learned nothing after a long day of *sheer joy*, spent barefoot on a glistening beach, coming home with a pocket full of seashells, agates, and sea glass to show for it? The sun, the wet sand, and slowly spreading sea foam lathering your feet; the smell of living and dying phytoplankton in the air; a cleansing breeze, the steep pine spice on wind and wave-carved bluffs—what could one possibly learn from that kind of sensory exhilaration? Philosophers say that emotions are too unpredictable; they are not under the control of the will and are thus unable to

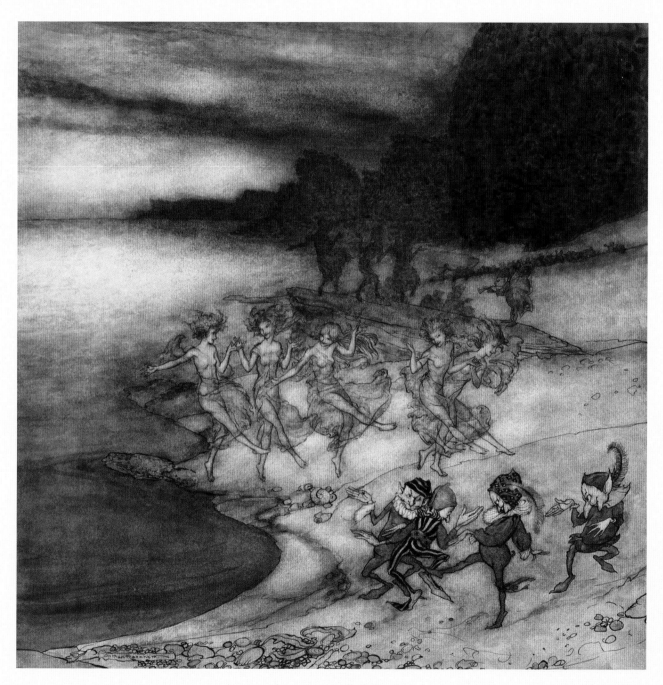

The sea was eventually challenged: The Pert Fairies and the Dapper Elves, *by Arthur Rackham.*

illuminate significant moral truths about human behavior. But "knowledge of the heart must come from the heart."

We go to the beach to ask questions of ourselves, about what matters in our lives, and what does not. We may go there to paint, to write, to read, to think, or to play with our family and friends. We may go to be alone. Time spent at the ocean has long been like a secret companion, or best friend, giving rise to thoughts about how to live our lives (perhaps importantly, what to avoid in life). We often go in search of ethical models, comparing our own fragility to the sea's untamed sublimity. Is the ocean itself a great moral teacher?

> *Style itself makes its claims, expresses its own sense of what matters . . . form is not separable from philosophical content, but is, itself, a part of content—an integral part, then, of the search for and the statement of truth.*[4]

Beach cottages of course, embody values and choices. More than mere taste is revealed in favorite paintings and photographs, well-read books, welcoming furnishings, crab pots and fishing gear. Seacoasts are places of revelation and of legends which wind through centuries—are these inventions or discoveries? Tempered by time, torrents and the tides, every seacoast and legend harbors its unique treasures, and seasons them with the currents and the flavors of authenticity.

These beloved cottages express their own senses about what matters.

1. Lena Lencek and Gideon Bosker, *Beaches* (San Francisco: Chronicle Books, 2000), 35.

2. Adam Nicolson, *Sea Room, An Island Life in the Hebrides* (New York: North Point Press, 2001), 26–7.

3. Ibid., 38.

4. Martha C. Nussbaum, *Love's Knowledge, Essays on Philosophy and Literature,* (New York: Oxford University Press, 1990), 3.

The beauty of some women was attributed to the fact that they could swim and were not fearful of the sea. Perimele, by Leonce Legendre ca. 1864

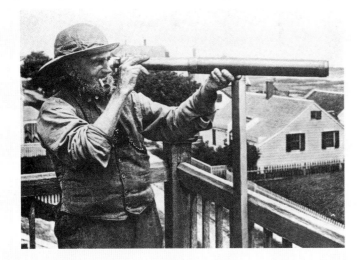

Old salt Billy Bowen scanning the surface of the sea. In the upper right corner of photo is Dexioma cottage.

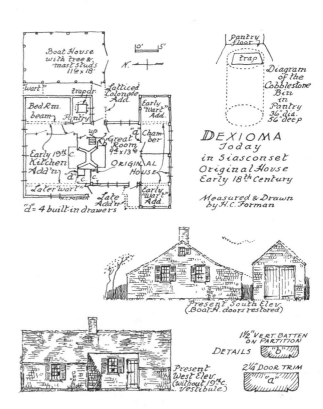

Measured to scale sketches of Dexioma, by H. C. Forman

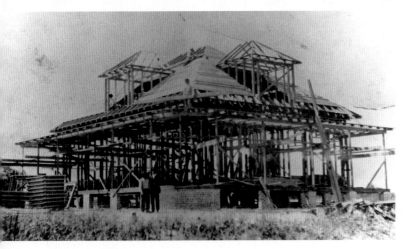

Early Tybee cottage under construction ca. 1890s.

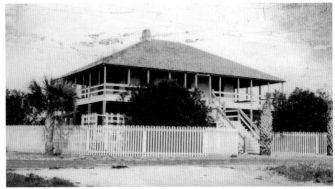

The completed Tybee Cottage design is typical of turn-of-the-twentieth-century Tybee Island architecture.

Genthe cottage in Carmel, original Genthe color photograph ca. 1905

The original interior of the spacious living room in the Genthe cottage ▶

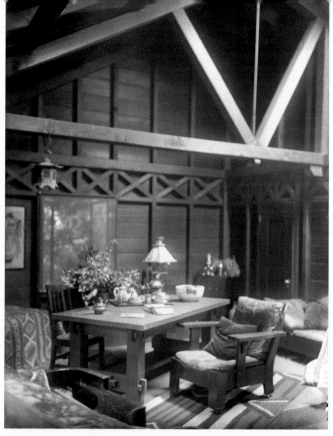

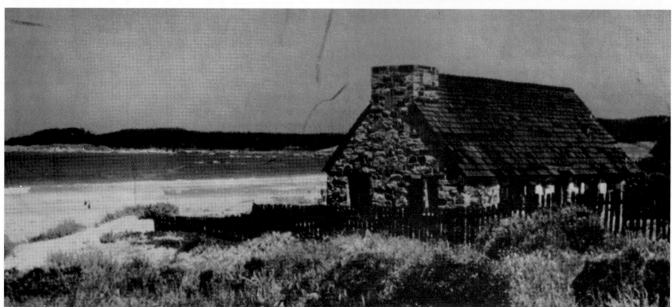

Carmel Beach Stone House before trees were planted near the beach, 1938.

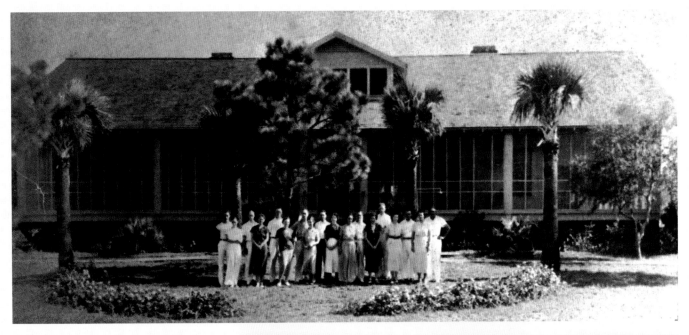

Henderson cottage when the palm trees were small; the first owners gather for a family portrait ca. 1936.

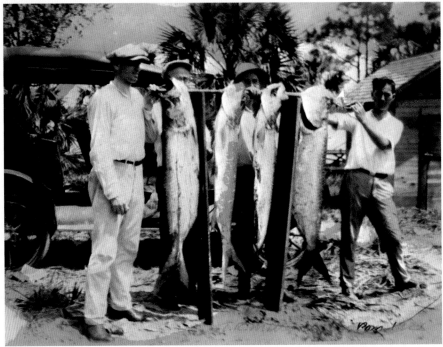

The day's Tarpon catch calls for a beach party.

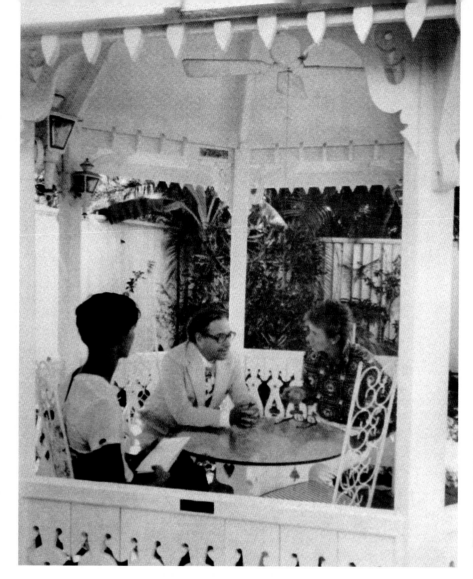

Tennessee loved spending time in the gazebo with friends.

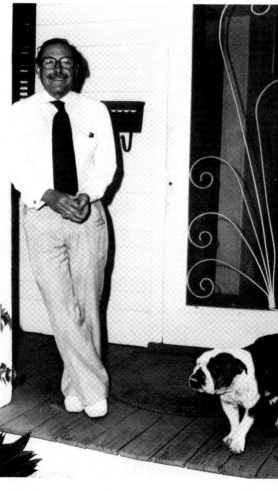

Tennessee stands with one of his many beloved bulldogs on the porch. Today, the screen can still be found on the front door of the cottage.

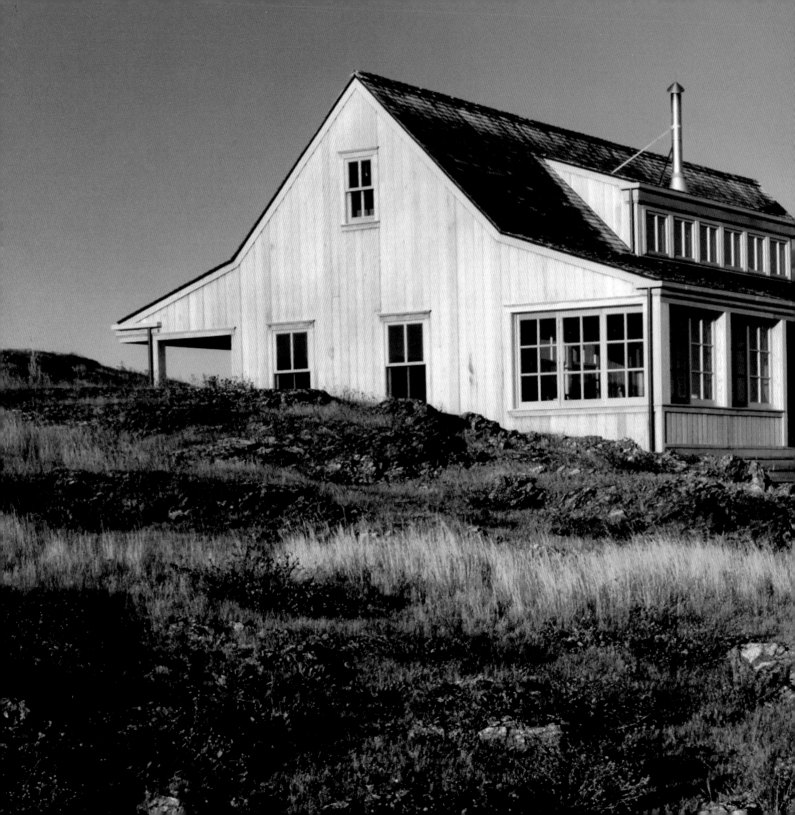

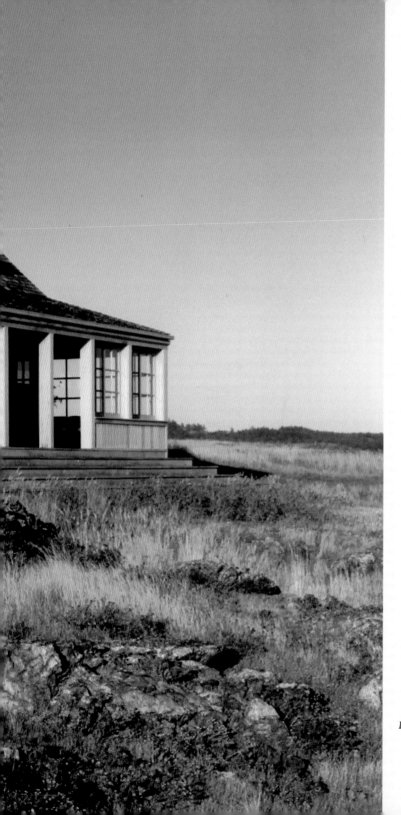

precarious shores

Desolate privation in the North Sound

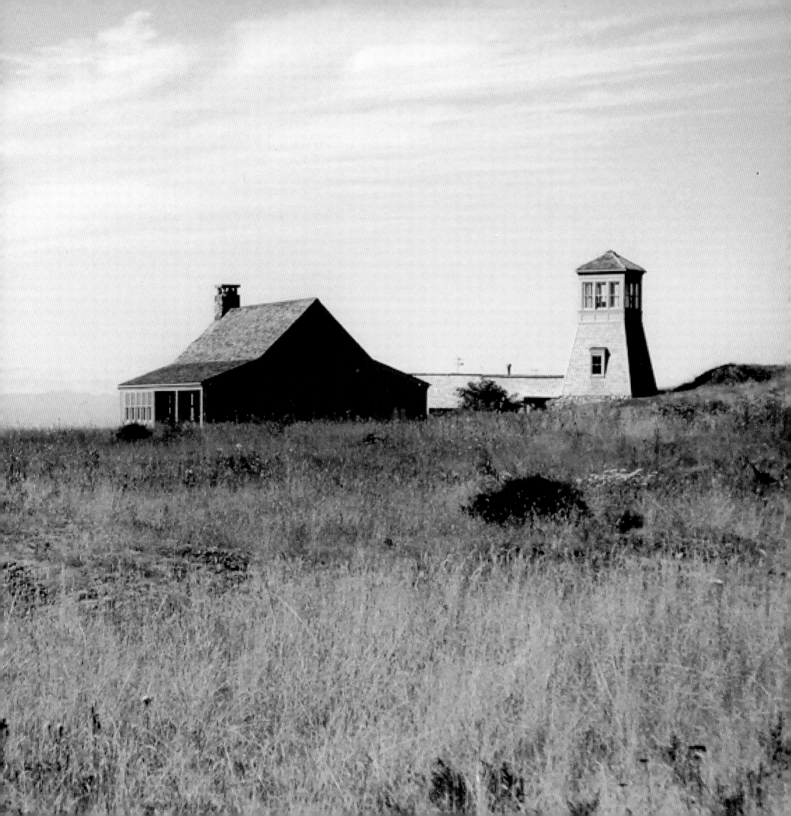

Windswept & Unforgiving

ARCHITECT: Thomas L. Bosworth, FAIA,
The Bosworth Studio, Seattle, Washington

PHOTOGRAPHER: Mike Jensen

BLACK AND BROKEN primeval rocks break through the barren sod and thin soil of this island. The landscape is a challenge to the presumption of hospitality on this far, northwestern island. Wild storms whip the coast; high tides scrape the crest of the windswept headlands. Shrubs and grass cannot get a roothold on the shoreline; Douglas firs stand, warrior-like, in the distance.

Building on an unforgiving slope such as this requires that the cottage be anchored firmly into the flow of native glacial rock. The architects designed a solid house and an observation tower. Minimal overhangs, that is, nothing that the winds could lift, were required. The floor plan is a variation on a Bosworth Studio design classic that uses the *enfilade* as its organizing feature. A deep porch, as wide as the cottage, is open to the ocean on one side and lined with a series of French doors that open into the great room on the other. The *enfilades*, or interior doors, allow activities in the living room, the porch, or outside in front of the cottage to seem continuous and limitless. When the *enfilades* are open,

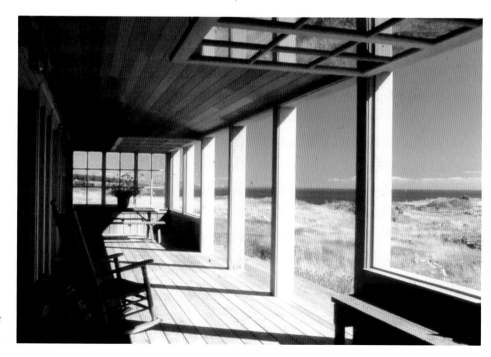

◄ *The cabin and tower sit on waves of native glacial rock.*

Storm windows are up and chairs are put out for a warm and sunny day.

the interior spaces have a full view of the bright blue waters. The porch is fitted with windows that can be lowered as wind screens.

The great room of the cottage is clad in clear cedar. Light enters it from dormer windows above, through bounced light in the transom windows, and through the room's French doors and windows. The kitchen is east of the great room, and a dining table is near its center. Niches in the north and south ends of the great room are built-in seats that can be closed off for naps or as extra beds for guests. Bedrooms are also at the north and south ends of the great room. Loft spaces above the bedrooms can accommodate children.

Family and guests enjoy walking the island in spring and fall, collecting the native delectables: *Cantharellus cibarius*, *Morchella esculenta*, and *Boletus*. With a basket full of wild mushrooms and freshly caught seafood, a festive afternoon is spent gathered in the warmth and smells of the kitchen. The cottage has a dining table that easily solves the question of who will clear after dinner: it flips over and transforms itself into a billiards table.

A desire to live and cavort with nature on her own risky terms is supported by this island architecture. The property is large and can be reached by ferry, canoe, or airplane. The driveway doubles as an airstrip for small planes. The architects were chosen to meet the demands of the owners' desire for simplicity and practicality; they asked for a cottage with the tenacity to face the west, the wind, and the wash of salt water. They got a design that accommodates the adjustments required by nature's turbulent moments and allows the delight of peaceful afternoons in the sun's long shadows with the prospect of a memorable sunset.

The reading tower is the catbird seat on this barren shore overlooking the waters of the Sound.

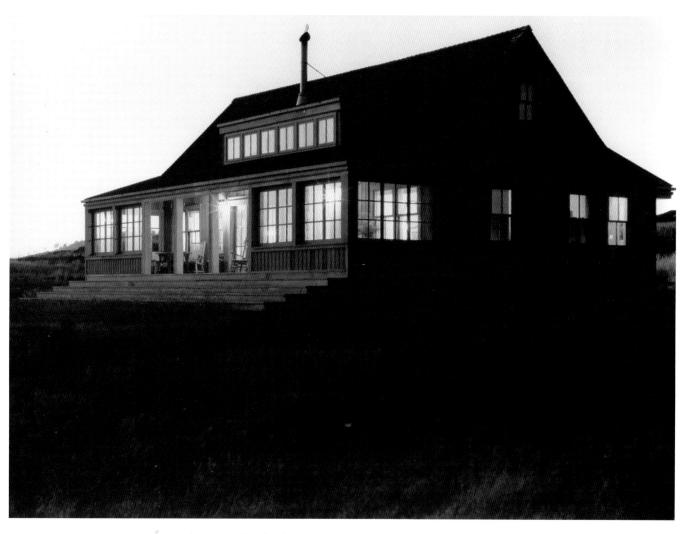

The storm windows close for the evening.

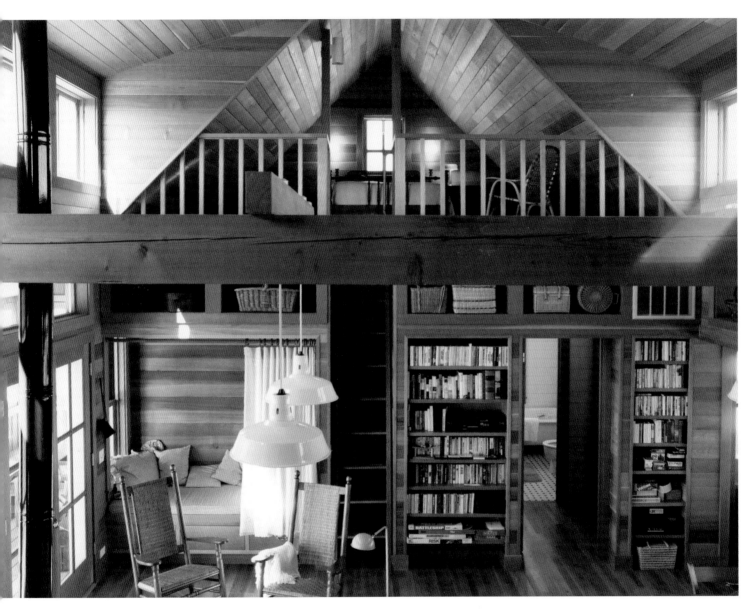

Enfilades and a clerestory bring light into every part of the cottage.

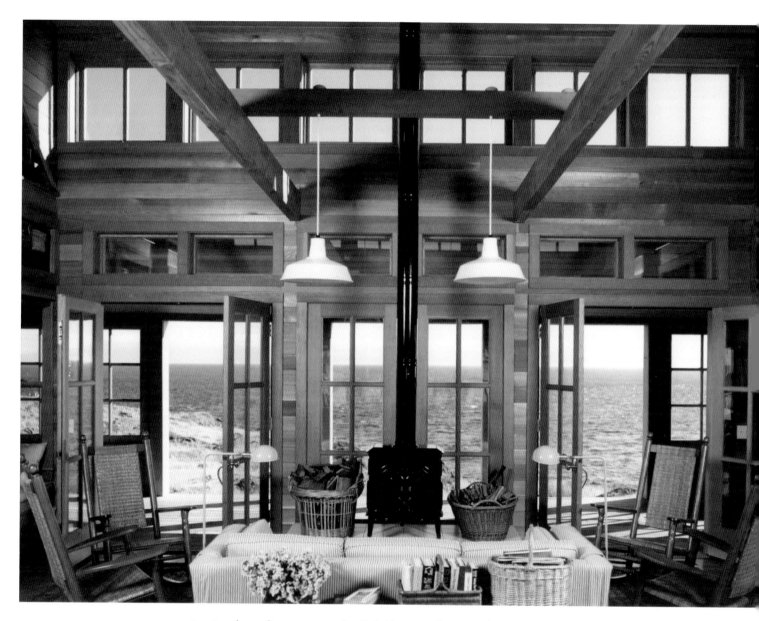

Interior cedar paneling contrasts warmly with the blue waters of Puget Sound.

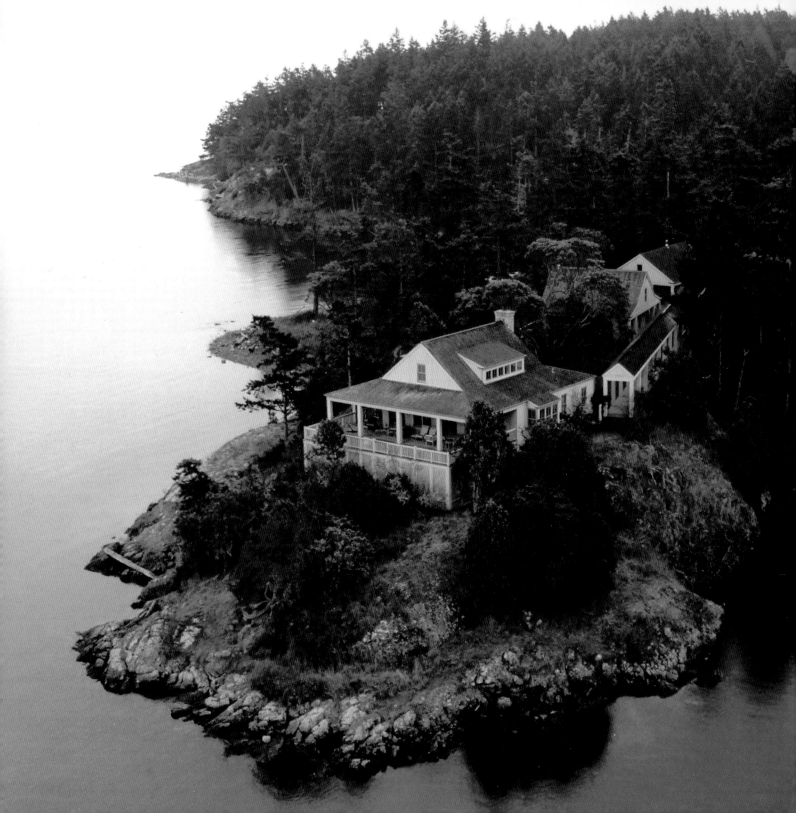

Rocky Outcropping

ARCHITECT: Thomas L. Bosworth, FAIA,
The Bosworth Studio, Seattle, Washington

PHOTOGRAPHER: Mike Jensen

Proportion and content are among the aspects of cottage living that enrich each and every return to one's favorite place; they help it to become a more natural and integrated element in the landscape. A cottage, though, is not simply a building as much as it is a collection of memories and dreams, sensations, activities, and explorations. Often it is remembered as a fragrance—spring leaves and buds unfurling in the air—or as the sound of a kayak being pulled up over a pebbled shore.

On a spectacular piece of land pushing itself into the cold waters of Puget Sound, this narrow and very rocky site was not an easy location on which to build a cottage. A single large building would have ruined the landscape. Thus, the architect was sensitive to preventing the site from being overwhelmed by one. Tom Bosworth's solution is a grouping of three small, asymmetrical buildings along the crest of the point. The main house is oriented toward the open waters and natural light. The bedrooms and guest quarters are in two separate, smaller buildings behind the main house. Both are oriented for ample privacy and framed, distinct views. The three buildings are connected by a long, narrow, classic loggia, which approaches each unit at an angle. Trees were preserved close to and among the buildings and decks and help frame the views. Wild grasses and native rock are used as

a border beside cultivated lawns, stone pathways, and the loggia. The main cottage takes a commanding role at the end of the point, with views and light in all directions. It is the place for indoor activity and entertainment, with a main gallery in which to display the treasures of beachcombing. There, where the kitchen, great room, music room, and fly-tying room are often all being put to use at the same time, the ideal of cottage living is in full swing. Often the voices, the music, and that special find from the beach blend into the landscape as inconspicuously as the changing patina of the cedar shingles of the cottages.

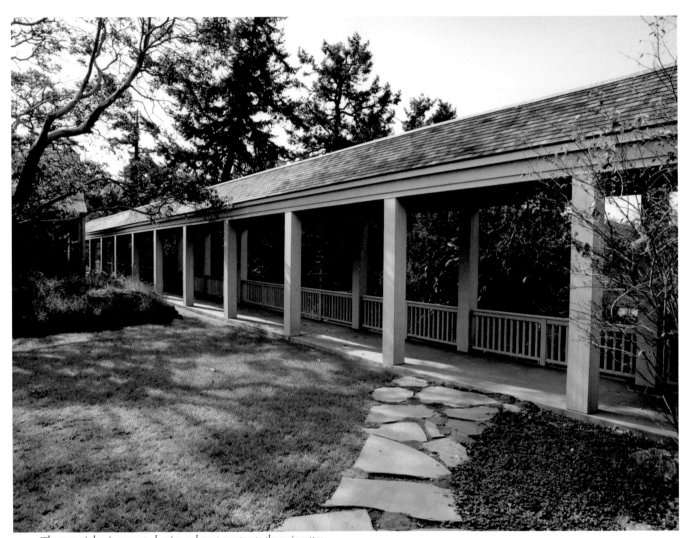

The open-air loggia connects sleeping and guest quarters to the main cottage.

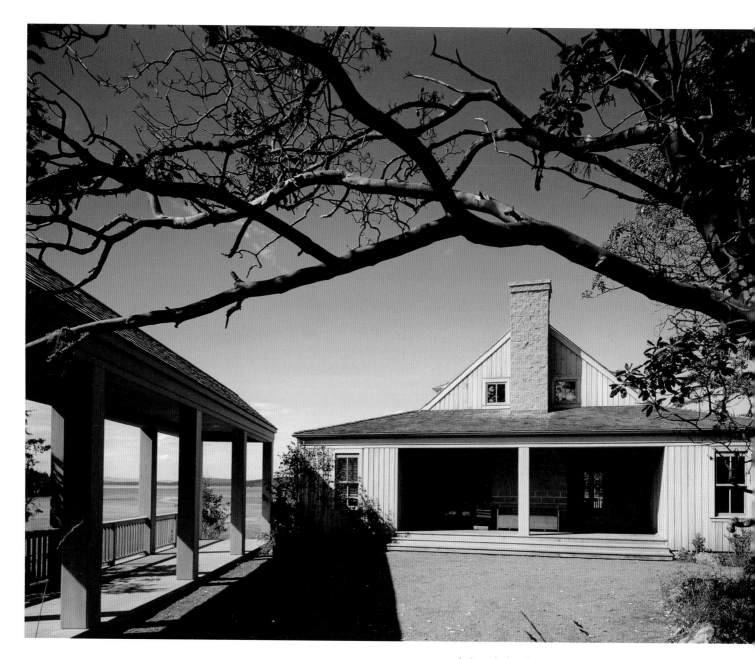

The loggia leads to the main cottage at the end of the outcrop.

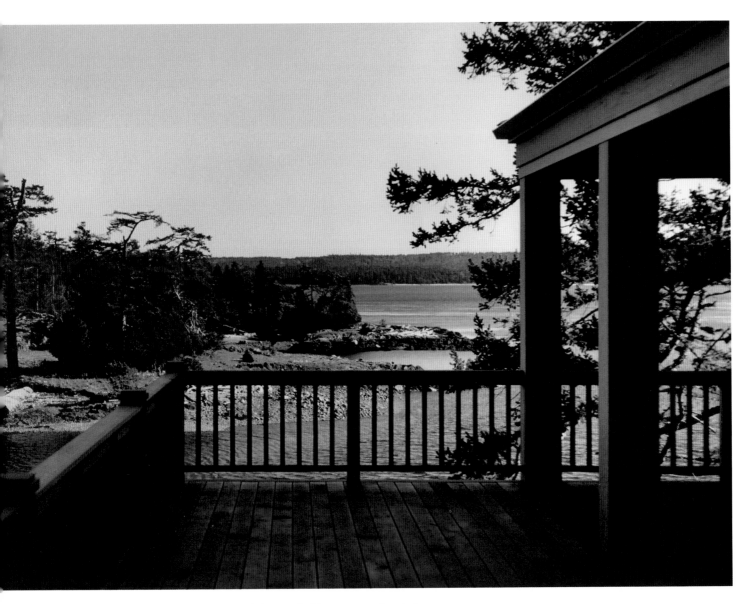

The large porch of the main cottage faces the bay.

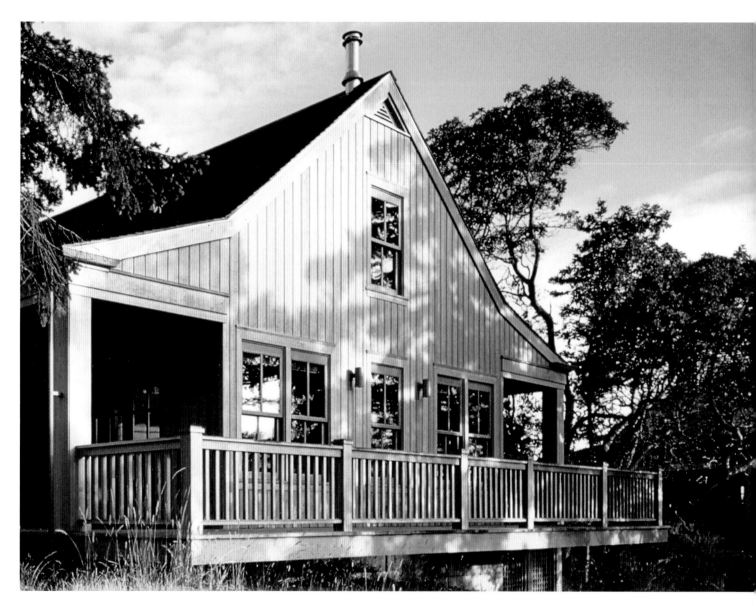

The cottage structures blend into the scale of the landscape.

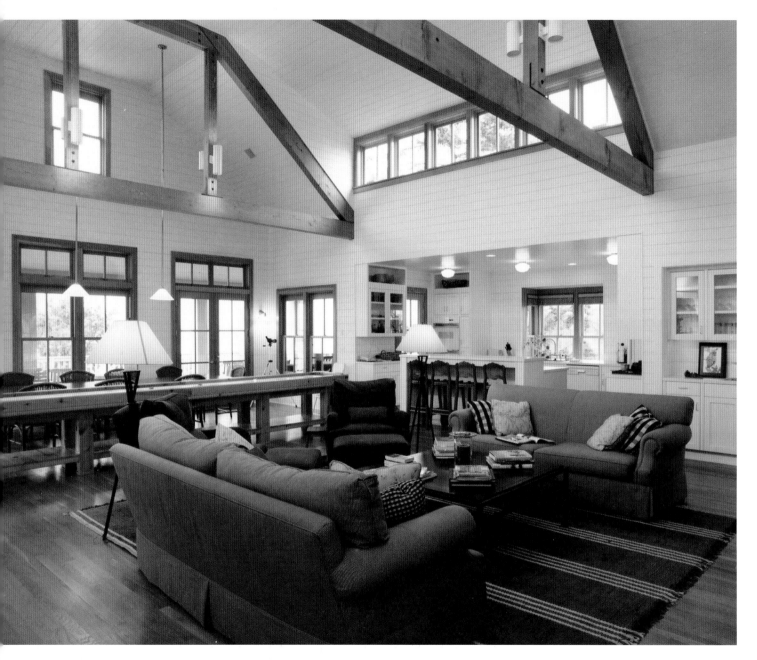

The main cottage houses the kitchen, music room, fly-tying room, and great room.

The separate master suite cottage is a bright and cozy respite. ▶

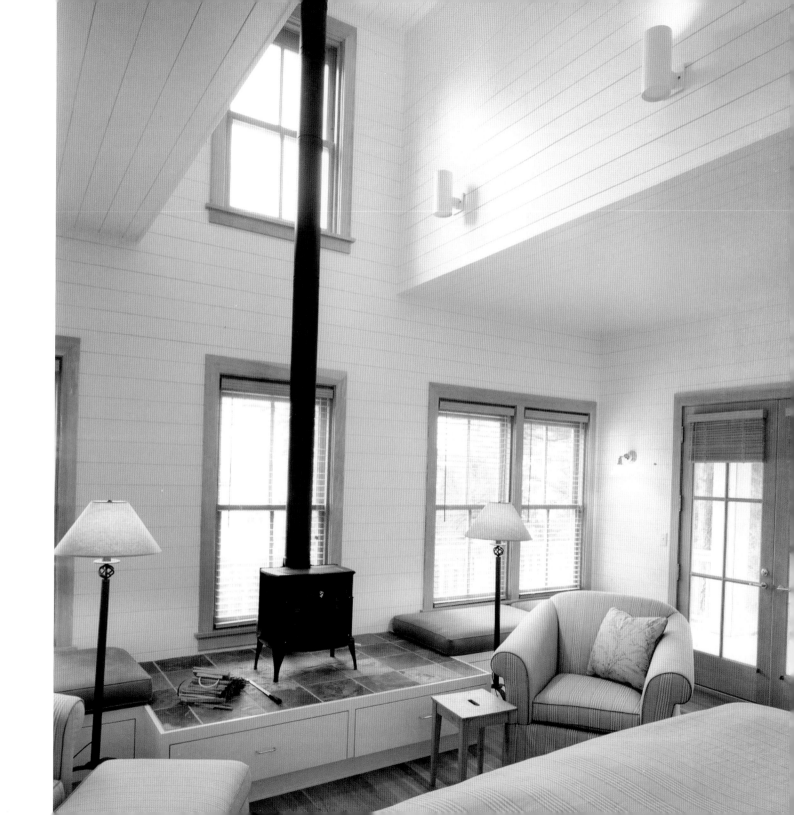

Vintage Vineyard Cottage

OWNER: John Molinari

ARCHITECT: Stephen Blatt, Principal;
Douglas W. Breer, Project Architect,
Stephen Blatt Architects, Portland, Maine

PHOTOGRAPHER: Brian Vanden Brink

ON CLIFFS high above the water, six acres of giant oak and maple and open fields of a rare and eerie landscape have sat untouched forever. The sand and clay Wequobsque Cliffs are 140 feet high, with a steep drop to the private white sandy beach below. The view is all sand and beach for twenty miles and this Atlantic wonder rivals any ocean setting in the world. In addition to the seasonal beauty of Chilmark, Martha's Vineyard, the surrounding landscape emits a scent of ancient, rare field air. Meadows and moors are stitched together by low, dry stack stone walls, which make good neighbors and call on the ocean to be a boundary, where it's needed.

A favorite activity is a trip into Menemsha, a small fishing village that is part of Chilmark, to enjoy a spectacular sunrise or sunset. Shopping for what the fleet brought in today might include choosing from bluefish, scallops, tuna, or flounder. An exhilarating part of the day is bringing home a market basket filled with fresh *fruits de mer* and cooking them over a hardwood charcoal fire.

The cottage was built to heighten the experience of being away from the city; to let visitors enjoy the sense of an earlier era in relative quiet and peace, even during the height of the summer season. It was built to offer a separate world, where the noisiest neighbor is the ocean.

The house is a collection of buildings connected in the manner of early New England vernacular architecture, where additions were built as they were needed. The main house is a kitchen with a sitting alcove, called "the nook." This is a favorite space, built of Douglas fir, with an arched wood ceiling reminiscent of a yacht and a fan-shaped entry. The beams were cut and milled by a close friend, who also carved the joints and brought the materials to the site by ferry. There is a barn constructed entirely with mortise-and-tenon joinery—no nails at all—where gatherings take place for watching movies and playing music. The sense of the place is completely informal— country and seaside, and meant to show its forthrightness. The design borrows from a collection of architectural styles and ornamentation, which, with a few modern innovations and indulgences, expresses an eclectic charm, replacing formality with delight, warmth, and even mischief.

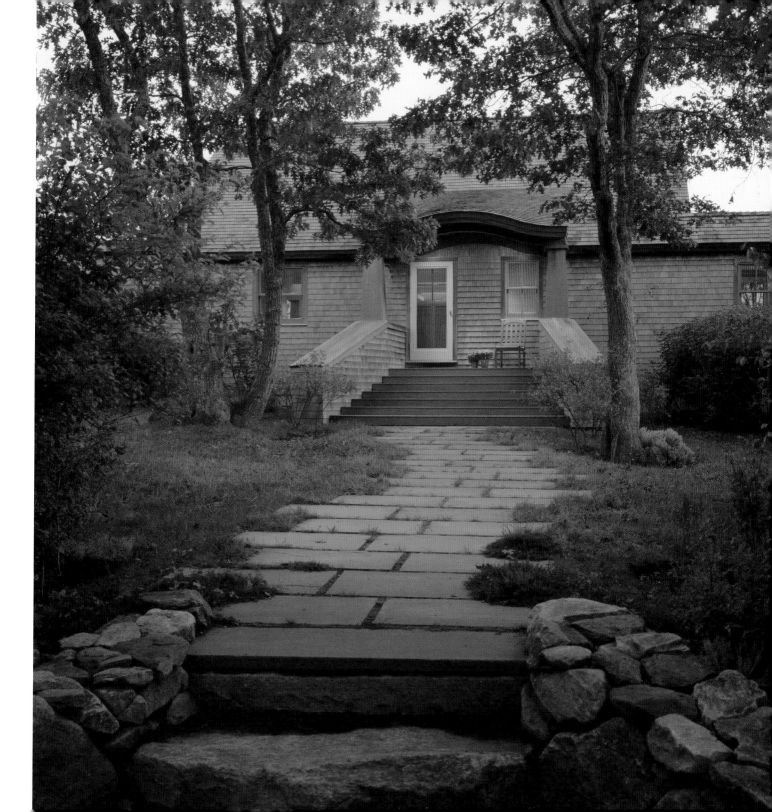

Space and serenity above the sea

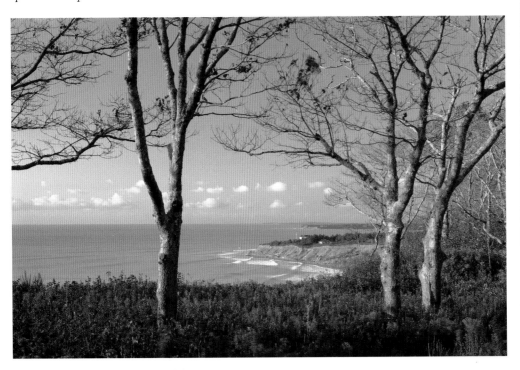

The noisiest neighbor is the ocean.

A collection of buildings sit atop Wequobsque Cliffs.

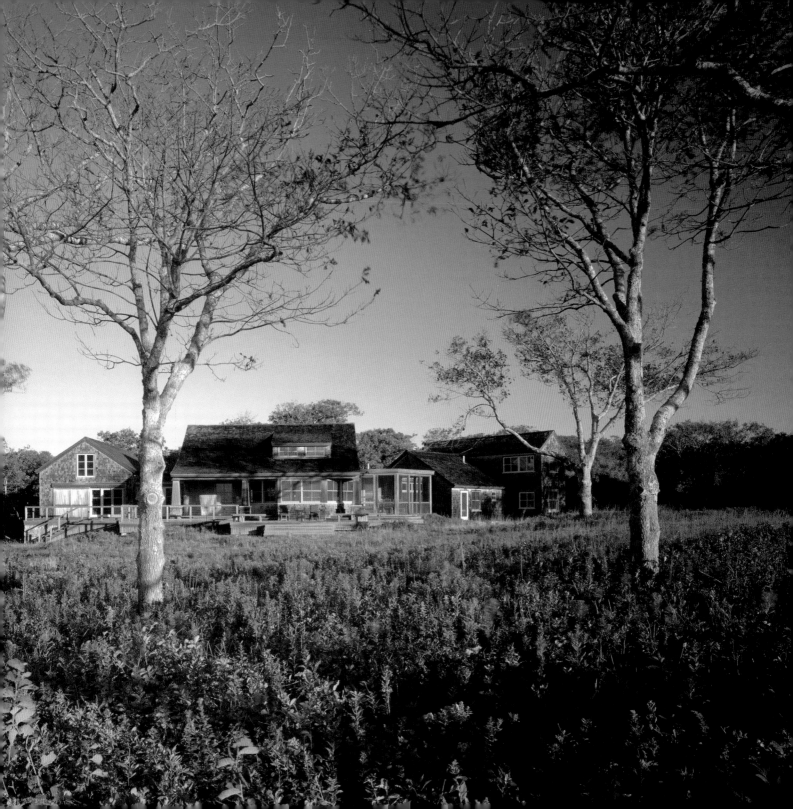

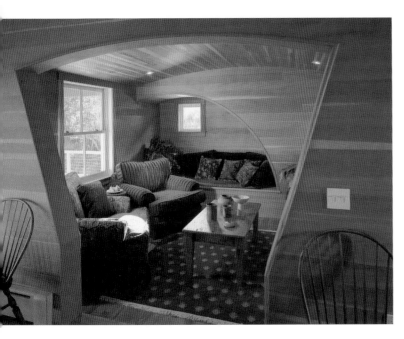

The sitting alcove, called "The Nook," is off the kitchen. An arched wood ceiling and a fan-shaped doorway create the sensation of being on a yacht.

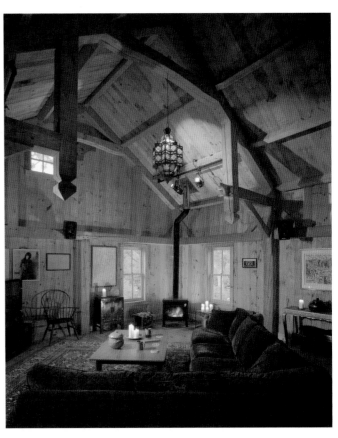

The "Barn" utilizes mortise-and-tenon joinery (no nails); Old World architecture meets high-tech toys.

The main house is the kitchen with a sitting alcove; a perfect place for festive gatherings. ▶

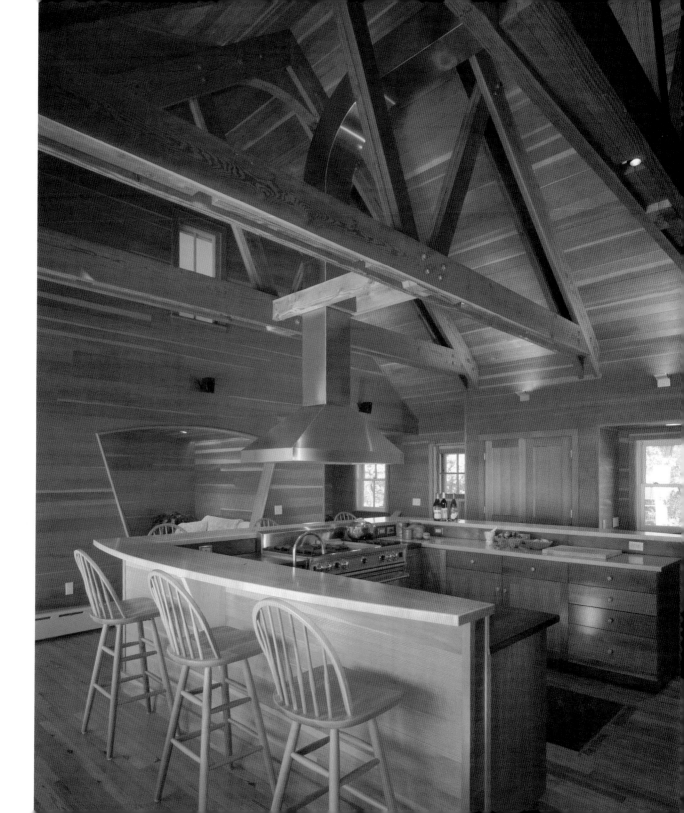

In a little time a new home adjusts to its "traditional" patina.

Rabbit Run

ARCHITECT: Botticelli & Pohl Architects, Boston, Massachusetts

PHOTOGRAPHER: Jeffrey Allen

THIS COTTAGE of large and dynamic spaces is intended to be enjoyed by the family and its future generations. The family matriarch is a painter; the patriarch and their three sons work together in the catering industry. This is a family that loves to work together and spend their leisure time together, especially when they are gathered in a place where there are lots of bunnies around ("Bunny" is a term of affection within the family). Deciding to build a new house on Nantucket Island, the family bought a set of cottage blueprints from a well-known architect. As discussions about the design progressed, it didn't take long to realize that a generic design would not satisfy, or, even with major modifications, be made harmonious with the needs of a creative and active family.

Botticelli and Pohl were brought in to consult on the changes. The "generic" plans were scrapped and a completely new design process began with an up-to-date look at the family's needs. The family had visited one of Botticelli and Pohl's Nantucket cottages and liked the open studded ceilings and the shingle style, so they started sketching a new approach.

The final design is a classic shuttered, rose-covered, shingle-style cottage that suggests late nineteenth- and early twentieth-century design. The open-vaulted ceiling spaces

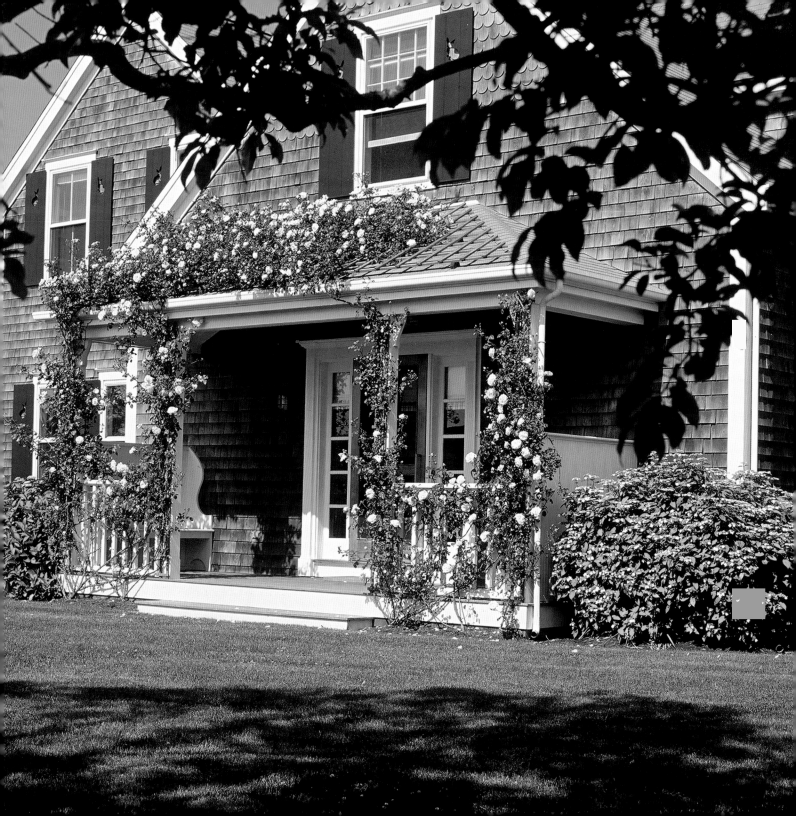

evolved from the idea of the open studs seen in the smaller island cottage. The large open spaces became the main design feature in and around which are arranged the living room space, a double staircase, and an open second floor landing with its dormer and the upstairs rooms. The interior floor plan vibrates with a contemporary flow. The main living area features three sets of French doors that open to the afternoon light. A large dining room holds a small, bright, breakfast nook. Both lead directly into a crisp, blue and white, 1940s-style kitchen.

Steps Beach is on the north shore of the island in Nantucket Sound. The water tends to be calmer and warmer than the south shore beaches, which are open to the Atlantic. The beach itself is flat and sandy with beautiful beach grasses. In the spring, the dunes are covered in fragrant *rosa rugosa*. Rabbit Run sits happily on a quarter acre of lovingly tended higher ground.

Rabbit Run is above the ocean; a walk to the harbor beach is nearby. The cut-out rabbit shape in the shutters was chosen from a family competition.

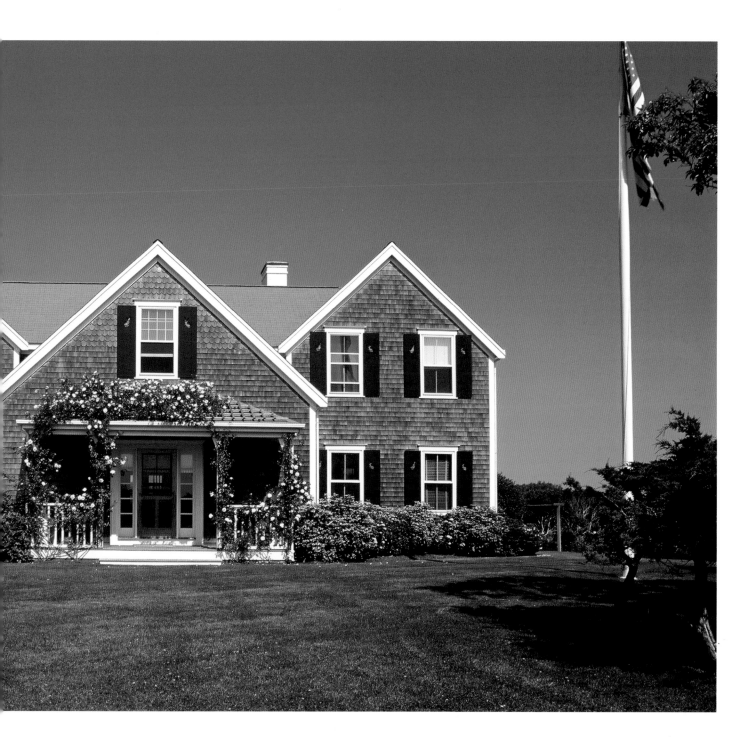

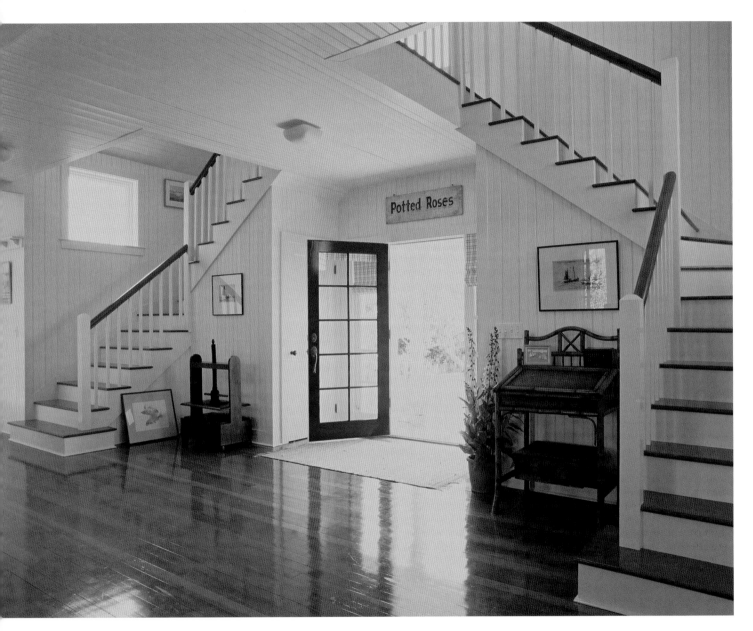

The front entry opens into a bright room under a double stair.

The living room is open to the landing and hallway above. ▶

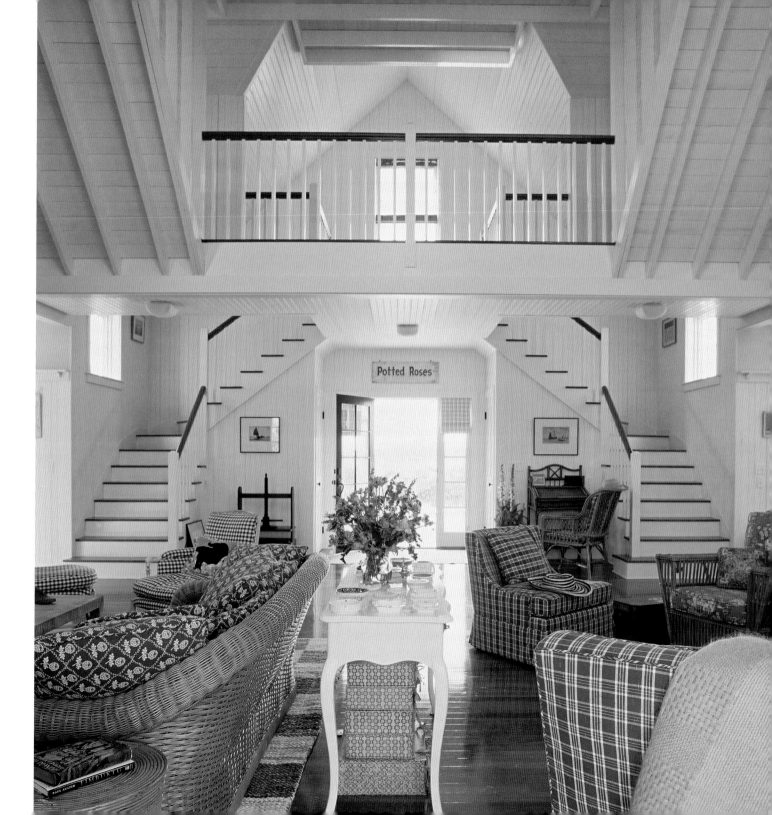

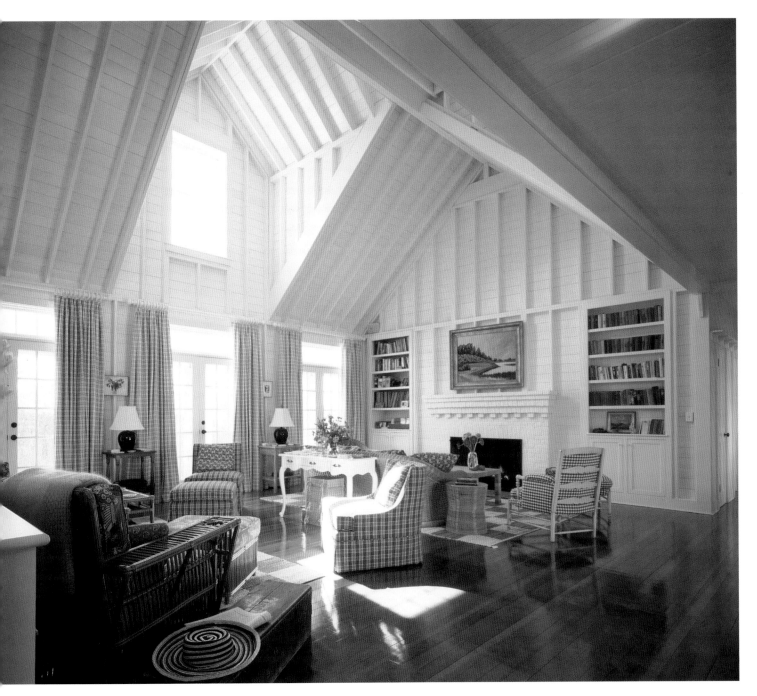

A contemporary openness featuring studded and vaulted ceiling spaces is refreshing and bright.

Crisp 2 1/4 inch blue and white tiles on the backsplash accent the kitchen. ▶

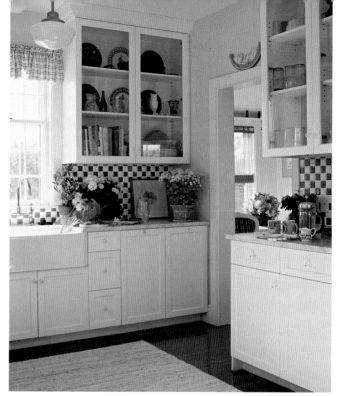

The dining room is next to the kitchen and is open to the great room.

A sunny breakfast nook exudes a stately informality. ▶

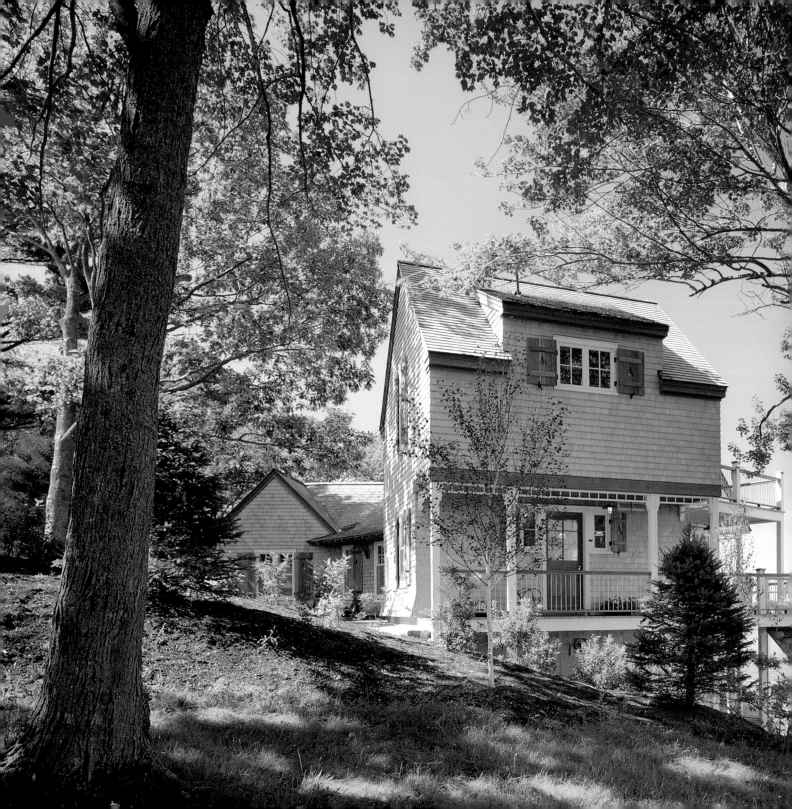

Ocean Point Cottage

ARCHITECT: Rob Whitten, Whitten Architects, Portland, Maine

PHOTOGRAPHER: Brian Vanden Brink

THE SOUND OF RIGGING hitting a sailboat's mast in Linekin Bay is all that can be heard here on a foggy day. Small islands to the north and south are hidden in the mist, and the sweeping views that the cottage at Ocean Point was designed to take in are obscured by weather. But this family is familiar with and comfortable in all of the changing seasons here. The owners are a couple in their mid-forties with two children. The husband spent forty memory-filled summers just two doors down, at his parents' cottage. It was a natural blossoming of the family to purchase this seaside site when it became available.

The architect was engaged to carry out the clients' clearly defined ideas about the cottage. Designed in the shingle style, the new cottage is intended to restore a sense of the old cottage vernacular to the area. In five years, exterior cedar shingles will have aged to a softer silver gray in the flourishing landscape. The cottage will acquire the patina of earlier eras and look as though it has been here for quite a long time. From their European travels, the owners collected ideas, such as the authentic working shutters that close and bolt over the windows. The door locks are brass boxes that have their tumblers external to the door itself and not inside the door like modern locks.

To balance the interiors with the aged feeling of the

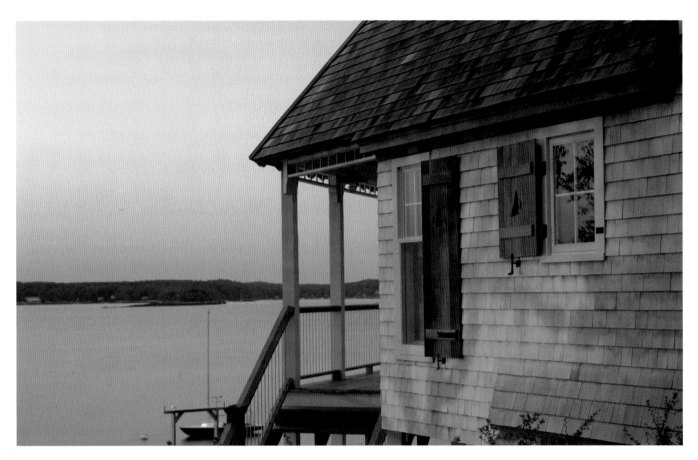

Simple lines, shingles and authentic working shutters on all windows add to the authenticity of the style.

exteriors, the clients asked the architect to incorporate lots of wood and rugged materials such as cedar, heavy beams, rough-sawn trusses, and brass fixtures. A carver and woodworker himself, the husband takes great delight in returning from worldwide business travels to the dozens of species of wood used throughout: teak countertops, and teak and holly kitchen flooring such as that found in yachts; cedar shutters and trim, and salvaged heart pine planks from a nineteenth-century warehouse; flame maple kitchen cabinets; and pine beadboard on every wall. Not one single sheet of drywall was used in the entire cottage. The wife, a schoolteacher, enjoys reading and writing, and, of course, having guests. Decks, patios, and seating areas allow for easy entertaining; separate clusters of spaces provide privacy as it

is needed. The cottage is completely technology free: no television sets, computers, digital readout appliances, or apparatus. The attention to detail applies even to the wall thermostats, which are an old dial type; nothing with a red or turquoise glow to upset the balance of a night at the water's edge. Life here is always focused on the water. Boating and swimming and fishing are its essence. The daughter and son love to ride the speedy "inflatable," in which trips to the nearby town of Boothbay Harbor are more fun than taking the car (and just as fast).

Cedar posts and beams and brass fixtures give the cottage the flavor of an earlier era. ▶

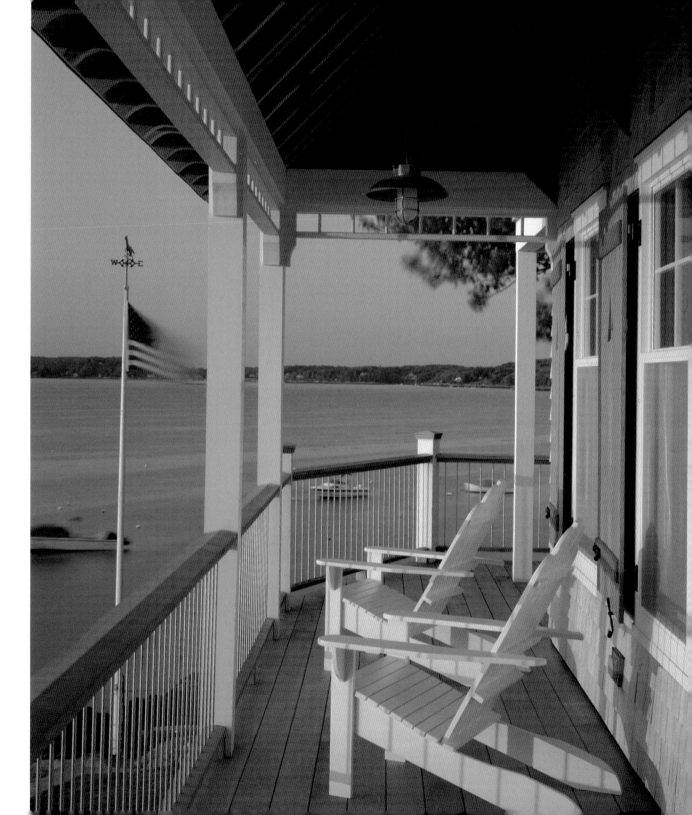

The cottage ambles on the site, providing many private areas inside and out.

The decks, porches, and stairs all lead to the bay. ▶

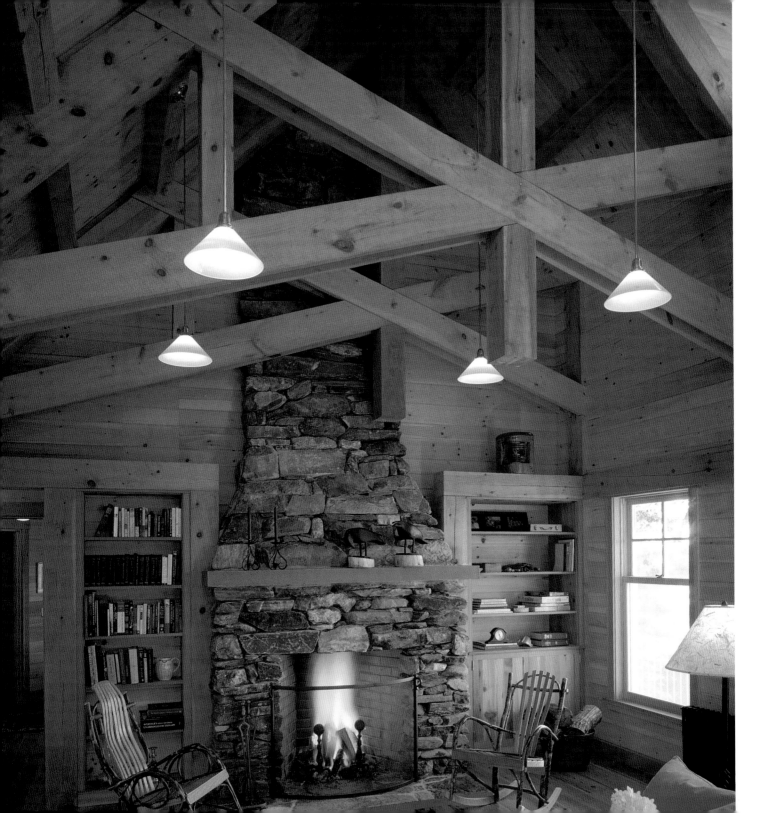

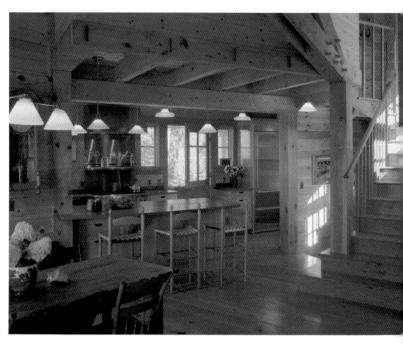

Teak counters, heart pine flooring, and flame maple
kitchen cabinets keep the interiors warm and inviting.

The stenciled armoire is a complement to the
country furnishings.

◄ The owner is a lover of wood and requested dozens of species
used with the ruggedness of stone.

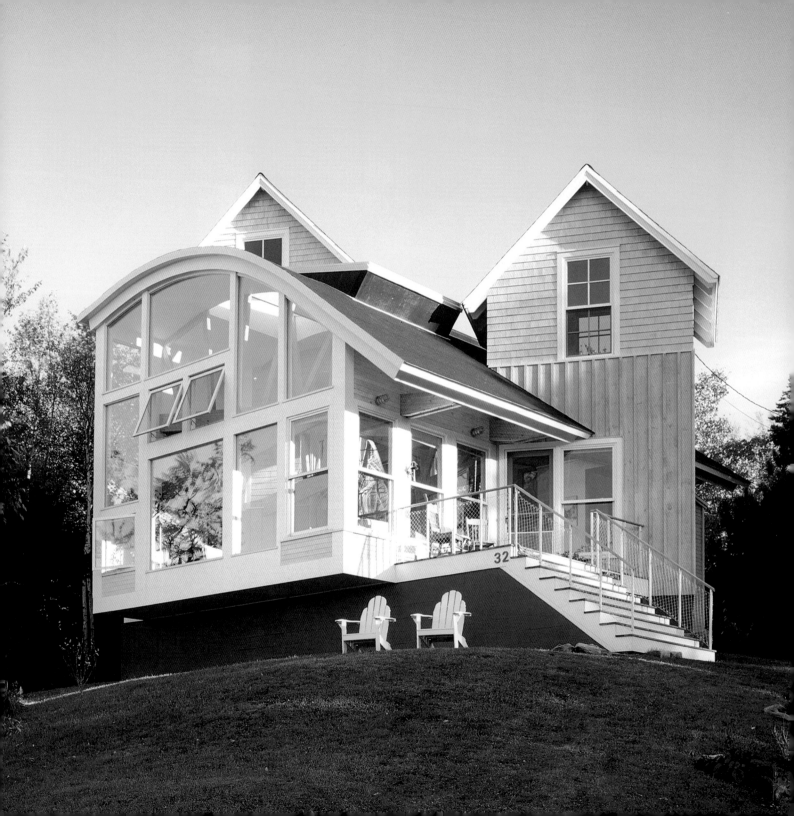

Evergreen Landing

ARCHITECT: Will Winkelman, Whitten Architects, Portland, Maine

PHOTOGRAPHER: James R. Salomon

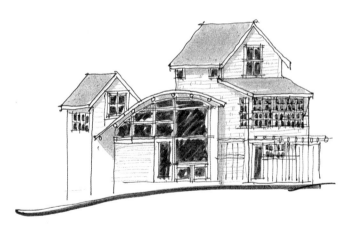

◄ *An old family vacation cottage is replaced by a light-filled adventure.*

ISLAND LIFE can be trying. The owner of this cottage at Evergreen Ledge on Peakes Island, Maine, wrote, "it can turn a trip to the grocery store into a safari . . . but any inconvenience is overcome by the beauty of the place." One of a small group of islands in Casco Bay, Peakes Island originated as a Methodist retreat community. Like many religious retreats of the early twentieth century on the east and west coasts, the housing was minimal. Often simple tents or tent "cabins" were provided, in which a half wall and floor were made of wood planks, and the upper half wall and ceilings were made of canvas.

The new cottage replaced the owners' previous turn-of-the-century cottage which, multiple remodelings notwithstanding, was consistent with neighboring architecture. The tight, sloping, waterfront site was set in a thickly populated seasonal community. The owners asked Will Winkelman, the architect, to design a three-season cottage, featuring a light-filled, two-story living-dining-kitchen space arranged under an exposed, trussed three-quarter-barrel-vaulted roof structure. The lightness of the roof and its field of skylights is reminiscent of the lightness of tents. The new design also incorporates two flanking "book-end" traditional island cottage forms to squarely face neighbors on the upside of the slope. One "book-end" contains bedrooms and the other houses the front entry. The traditional proportions of these two typical island architectural components draw the structure together as a whole and insert it effortlessly into the surrounding neighborhood. While inside, the owners enjoy their dream-come-true cottage with its three bedrooms, two baths, and a dorm room for the grandsons on the third floor. All of their needs have been met in less than 1,850 square feet.

Peakes Island has been a family vacation destination since the sixties. Over time it became a bigger part of life for this family and now, with frequent and dependable ferry service, nine months of the year are island months. Summer is devoted to picnics, fishing and boating, and gardening. And many, many hours in the living room just reading and looking out over the water at the incomparable north-facing views of Great Diamond Island and Casco Bay, in all seasons and weather.

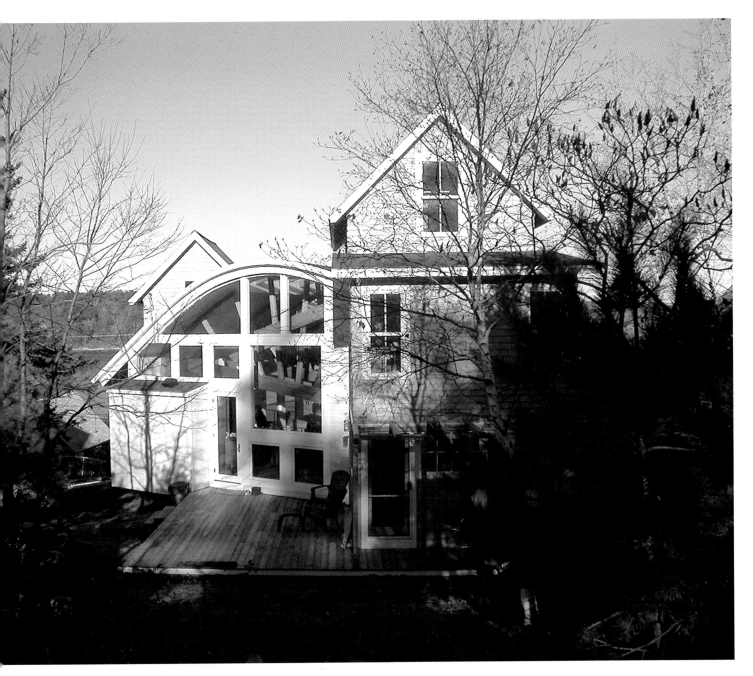

Downslope from neighbors, the new retreat reveals its traditional cottage "book-end" forms.

Interior lighting fills the exposed, trussed three-quarter-barrel vaulted space with the activity of architecture.

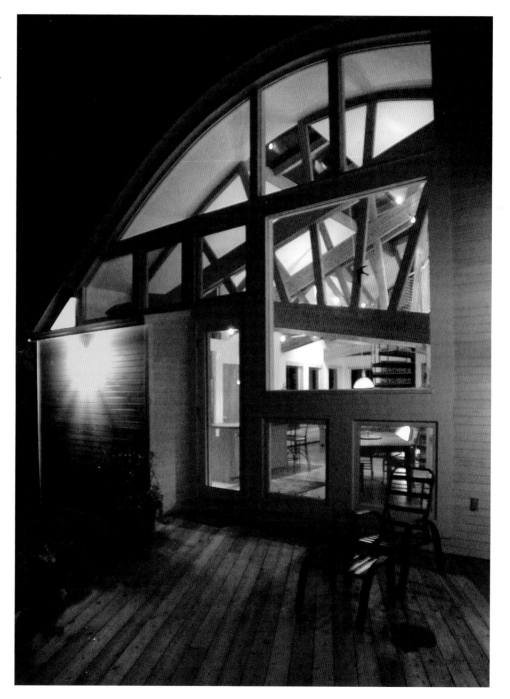

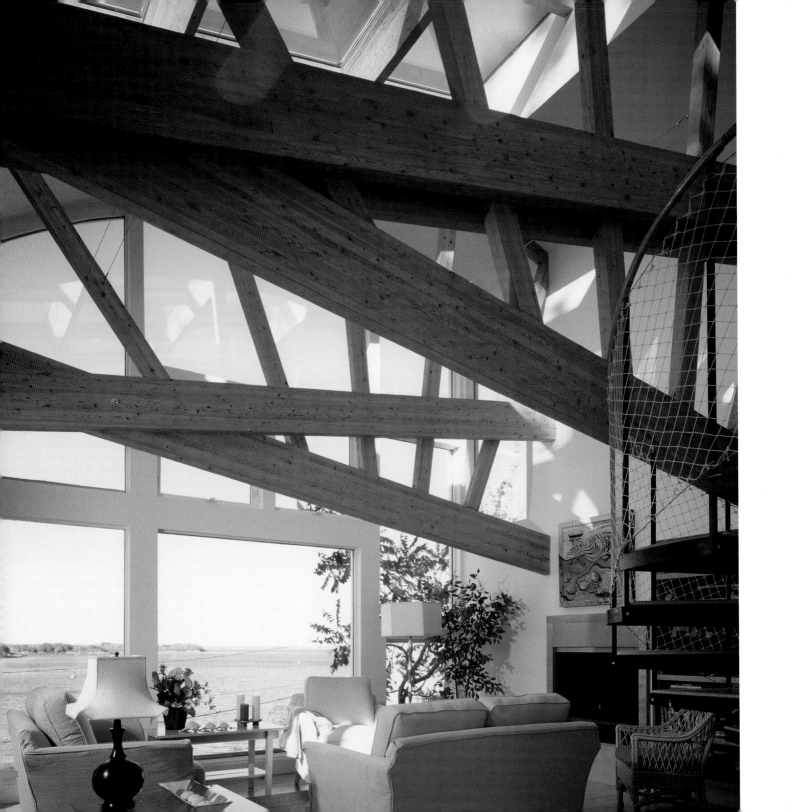

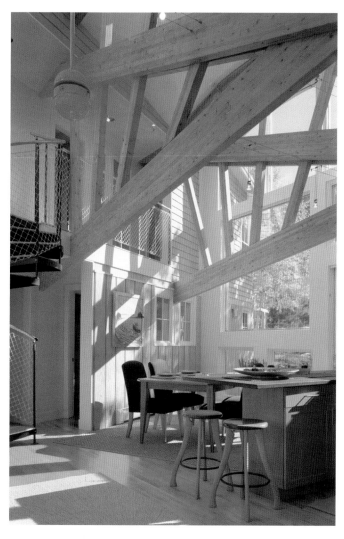

Kitchen and dining areas share the openness of the living room.

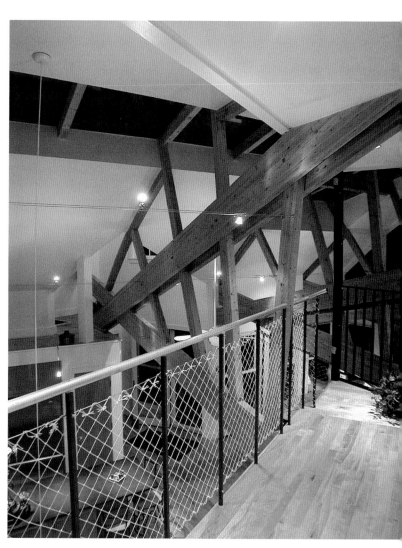

The loft landing looks down into
the kitchen.

◄ The two-story living room with glass vaults overhead,
fills the interior with natural light. A spiral stair leads
to the loft.

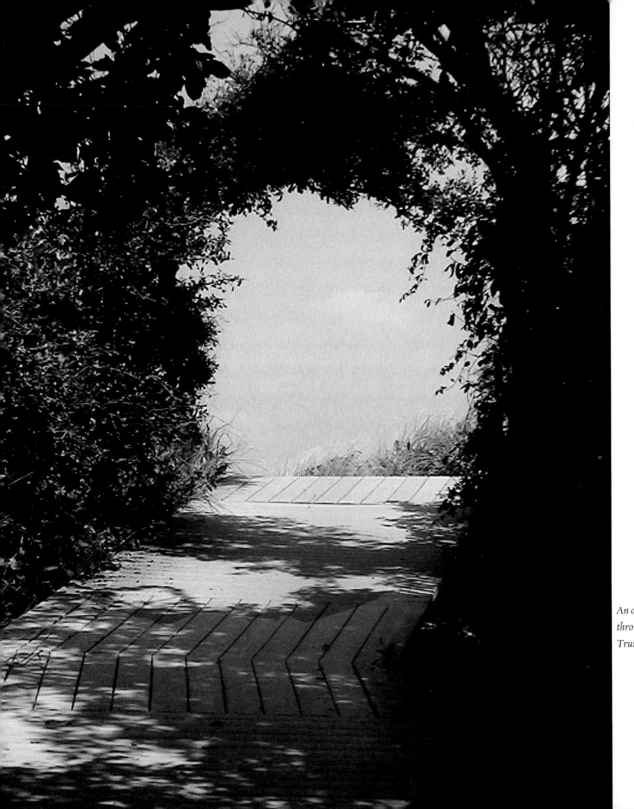

An ocean path over dunes,
through tunnel of
Trumpet vines to the beach

barefoot in the sand

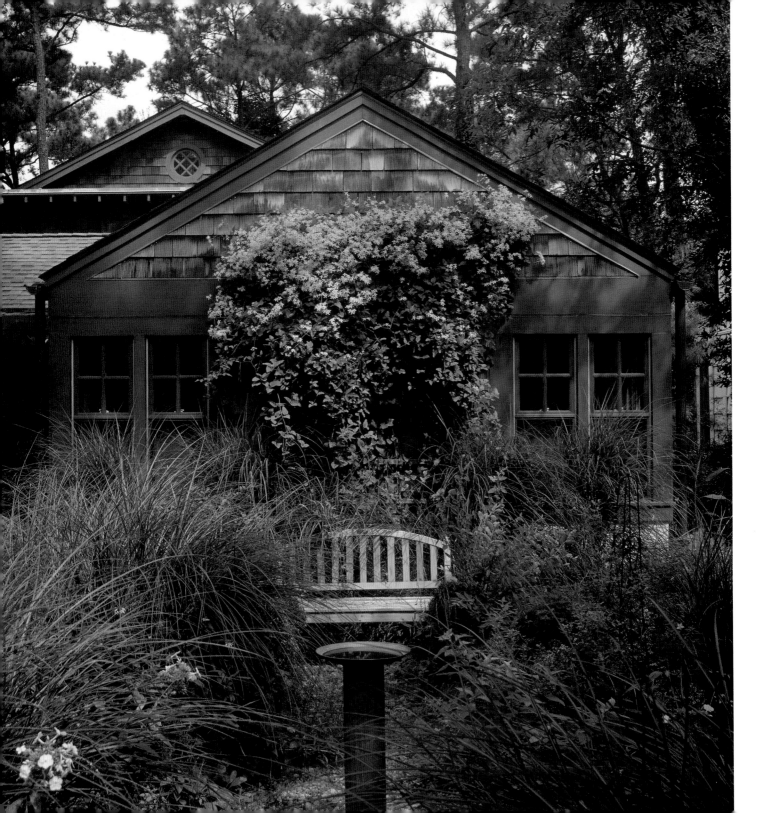

◄ A cottage garden of grasses, herbs, perennials, and vines

Virginia Beach Cottage

OWNER: Carvel Taylor-Valentine

ARCHITECT: David Linzee Amory, AIA,
Amory Architects, Brookline, MA

PHOTOGRAPHER: John Wadsworth

An entry is introduced by an arbor and native plantings.

A SEASIDE COTTAGE is a gathering place for a generation or two, or perhaps more. This new Virginia Beach cottage, however, is designed for the gatherings of three generations. The architect and his wife, Sukie Amory, a gifted garden designer, were asked to balance the design and scale of the new cottage with respect for the old and increasingly rare loblolly pines; to replace a lawn with exquisite native flora; and to integrate the overall endeavor into the incantations of the nearby ocean surf breaking against the sand. A design team more sympathetic to these clients' needs couldn't have been found.

In keeping with local tradition, the main entry is low profile and introduced by an arbor and native plantings. The second floor of the cottage steps back above and behind the entry, occupying space further back in the trees on the site. David Amory, however, is an architect who likes to incorporate an element of ebullience into his designs. He regularly puts underutilized or ignored spaces to use in completely new ways. In the Virginia Beach cottage, for example, Amory carries the concept of the sea wave, or even its larger form, the ocean swell, into the cottage's interior ceiling forms. An unanticipated and overwhelming surprise

The two-story screened porch has a special treehouse space on the second floor.

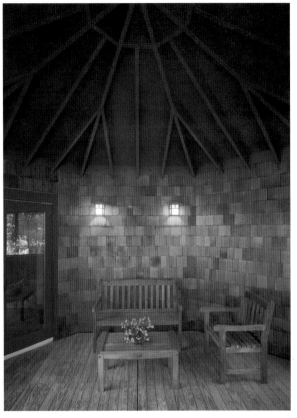

A sleeping porch in the loblolly pines is perfect for visiting grandchildren.

greets a visitor who approaches through the entry parlor. Its flat, cedar ceiling opens into a massive, light-filled undulation over the living space and then leaps the boundary of the upstairs railing and pushes ever higher to an arched crest under the roof ridge, before sliding down into smaller troughs and peaks. A seashell couldn't be more joyful. For Amory, design requires that his clients experience the delight of the space over and over again, each time in a different way. The architect designed this cottage for three generations of the family by creating separate living areas for each. The first floor is occupied by the clients. An adjoining apartment, second-floor guest rooms, bunkrooms, and a turret-like

sleeping porch-cum-treehouse in the pines are taken by visiting family members and their guests.

By using the exterior essentials—red cedar shingles, garden arbors, porches, and roof overhangs—the architect and garden designer sought to blur the distinction between structure and landscape. A new cottage is gently hidden by a garden of ornamental grasses, herbs, perennials, vines, rose-covered arbors, clematis and passion flowers, oak and pine trees. The tall, slender windows in the living room and sunroom open onto a terrace that is enclosed by the native woodland garden: loblolly pines, hollies, and live oaks. This cottage is reminiscent of classic 1910–20s Virginia Beach vernacular architecture but has a future of its own.

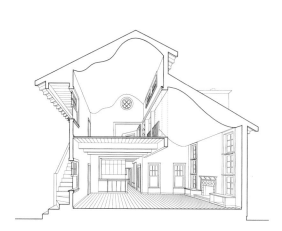

A section perspective illustrates the wave inspired ceiling forms .

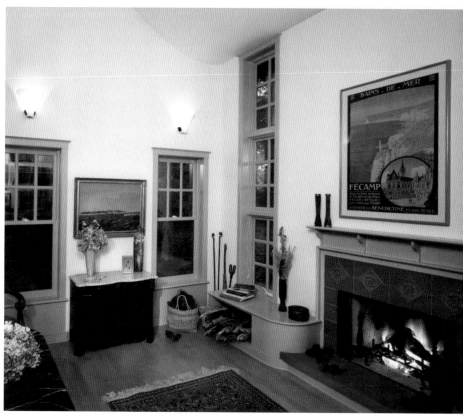

The light-filled living room where ceiling begins to soar up and over the loft space

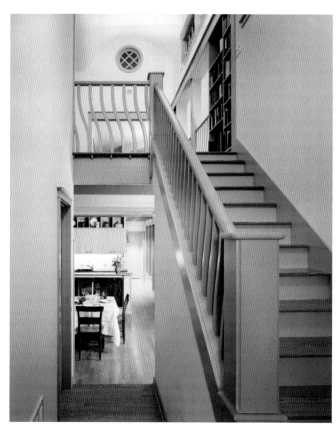

Colors and forms create an uplifting interior.

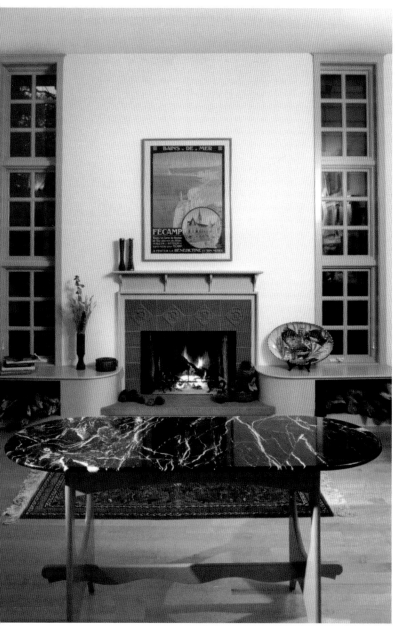

Tall, narrow windows are a focal point in the living room.

The curvilinear wave line of the ceiling opens to the second floor landing with a playful spaciousness. ▶

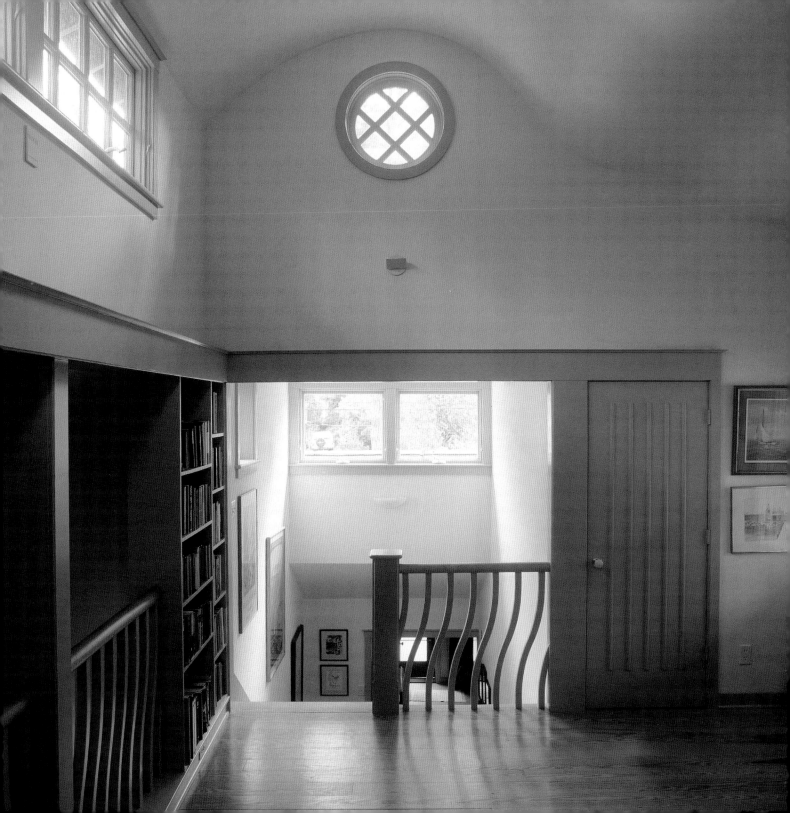

This stone seaside cottage is sheltered by a cypress tree that was planted after the cottage was built.

Carmel Beach Stone Cottage

ARCHITECT: C. J. Ryland, Architect

PHOTOGRAPHER: Michael Mathers

C. J. RYLAND, the architect of this cottage, described his tiny bit of perfection in this way: "It is really an example of the architecture in its simplest form, being of Carmel stone walls, with the stone exposed on its interior, and of hand-hewn redwood timbers and shakes cut from our local forests of the Carmel Valley. It is truly an indigenous structure." The cottage was built on the dunes of the Carmel beach in 1934, long before the cypress trees were planted. The entry is on the sheltered east side of the cottage, away from rough weather coming off the ocean. Ryland's intention was to design a sturdy rock and heavy timber house to withstand rugged coastal conditions similar to those on the west coast of England and Ireland. Many of the cottages in Carmel are reminiscent of English, Welsh, and Irish stone cottages. The roof is steeply pitched with a small eyebrow window facing the seas. Walls are carefully laid using Carmel's signature chalk rock. The windows are long, narrow, mullioned casements, and the west wall has a slanted bay, half-stone, half-paned glass. Originally only nineteen by thirty-six feet, this small cottage was designed to accommodate future additions without a loss of its architectural integrity.

A June 1941 issue of the *California House and Garden* magazine featured the Carmel Stone cottage. It was described as "quaint, fascinating, intriguing," with a "rainbow of colors . . . woven into the stone." The article claimed that

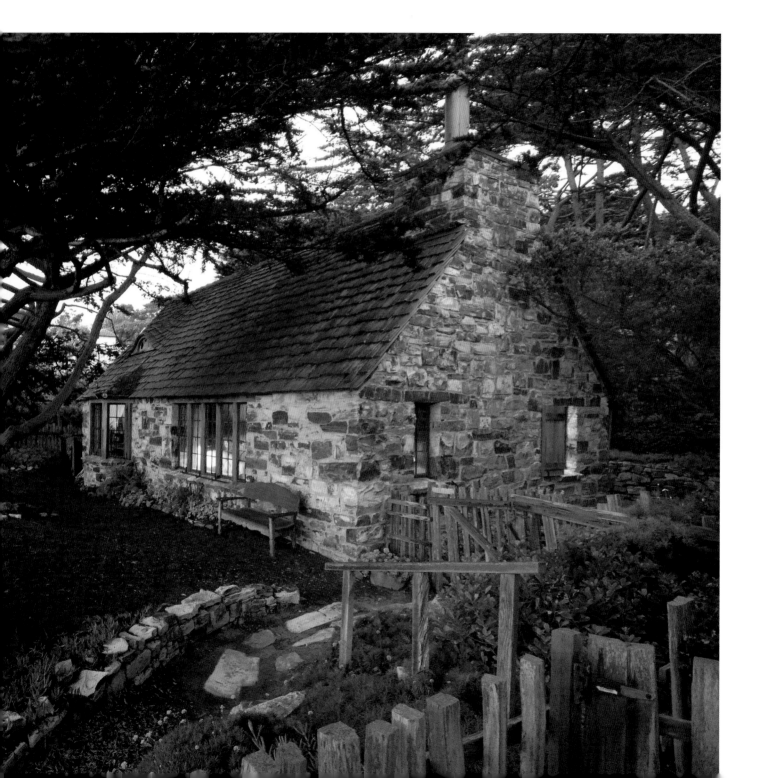

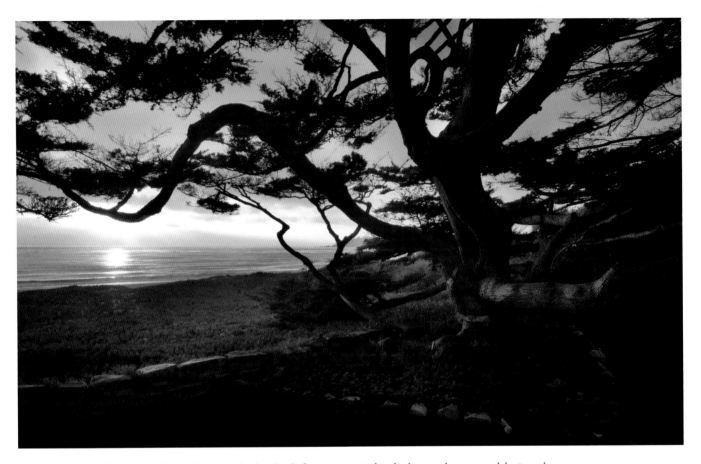

Nothing lies between the cottage and the Carmel sunset.

the cottage could be built (depending on the locality) for $5,000 or a monthly FHA loan payment of $43.65. Shown with the shuttered windows and the chalk stone paths and patio, the irresistible dwelling, numbered *House Plan 1015,* could be ordered directly from the magazine.

The "growth" of a cottage, or its capacity to grow, is integral to its character. Ryland knew that the best form to use when considering future expansion was the rectangle. The most intimate communities are those in which the cottages begin as one- or two-room shelters. Additions are added when needed and removed if they no longer serve a purpose. Those with a workable design remained and provided foundations for later additions.

The Carmel Beach stone cottage was so attractive and functional in its original form, with its warm redwood interiors, that Mrs. Clinton (Della) Walker rented it for some time and wished to buy the cottage. (Unable to do so, she continued to live in it until her own cherished 1,200-square-foot cottage, designed by Frank Lloyd Wright, was completed on the beach. A board-and-batten addition was completed in 1986 to accommodate a bedroom and bath wing. The beauty and character of the cottage is enriched by it and grows with every ensuing beach era.

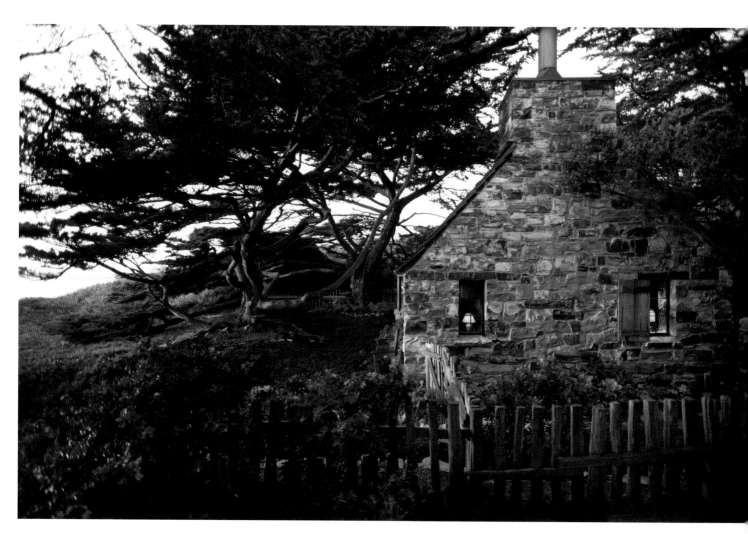

The cottage's buff-colored Carmel chalk stone turns golden in the setting sunlight.

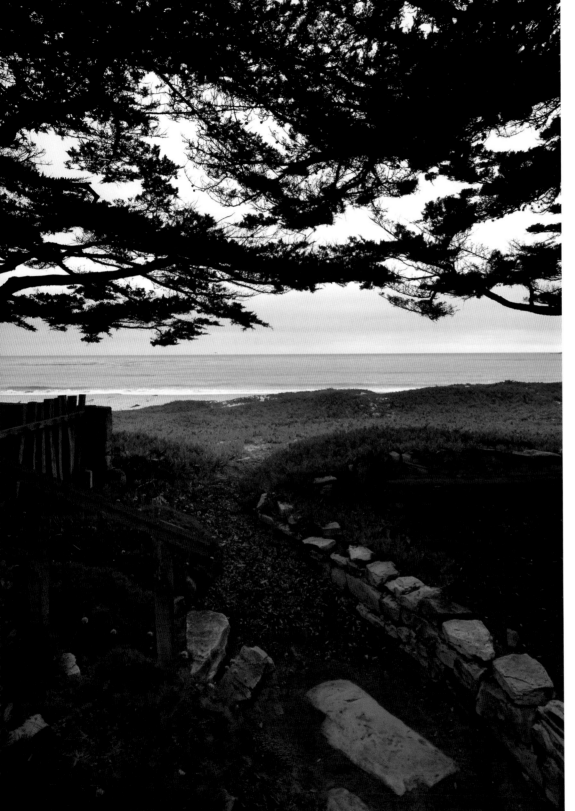

The headlands of the beach covered in ice plant grow directly in front of the cottage.

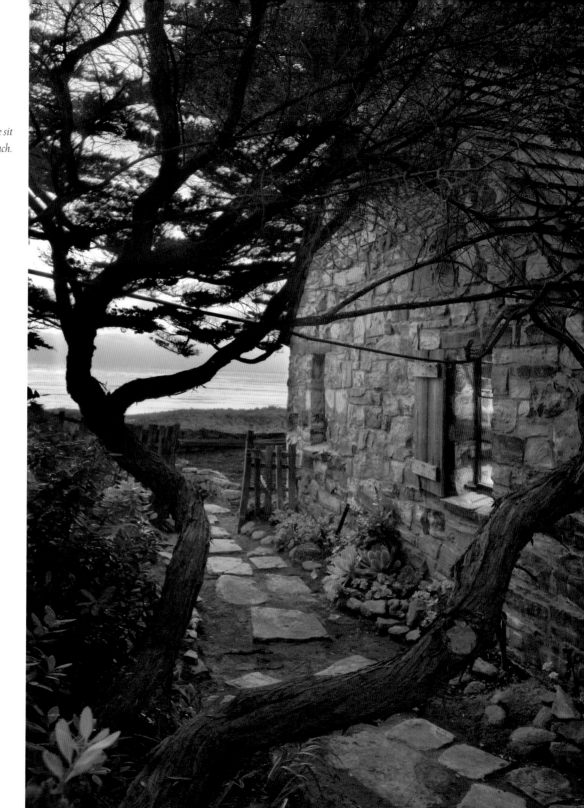

*A crooked tree, path, and fence sit
beside the stone cottage on the beach.*

*Architect C.J. Ryland designed and finished the interior in
redwood, with planks and hand-hewn timbers.*

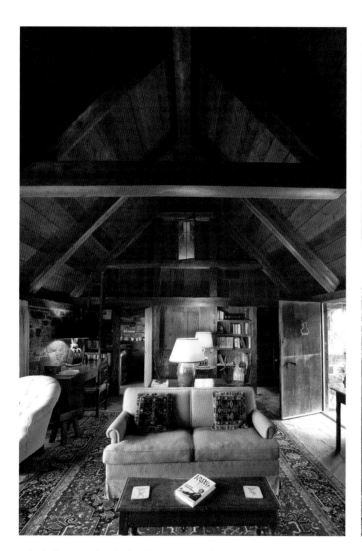

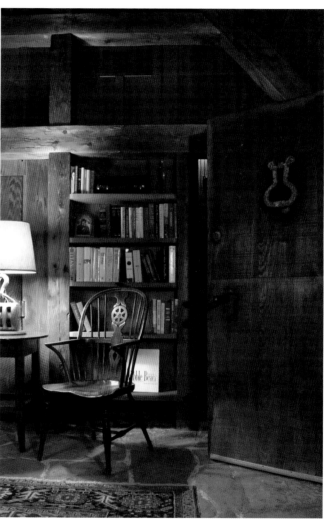

The chalk stone rock and redwood cottage was built to withstand rough ocean conditions.

Rough timber framing and the heavy redwood planking of the door and stone floor makes the cottage a true indigenous structure.

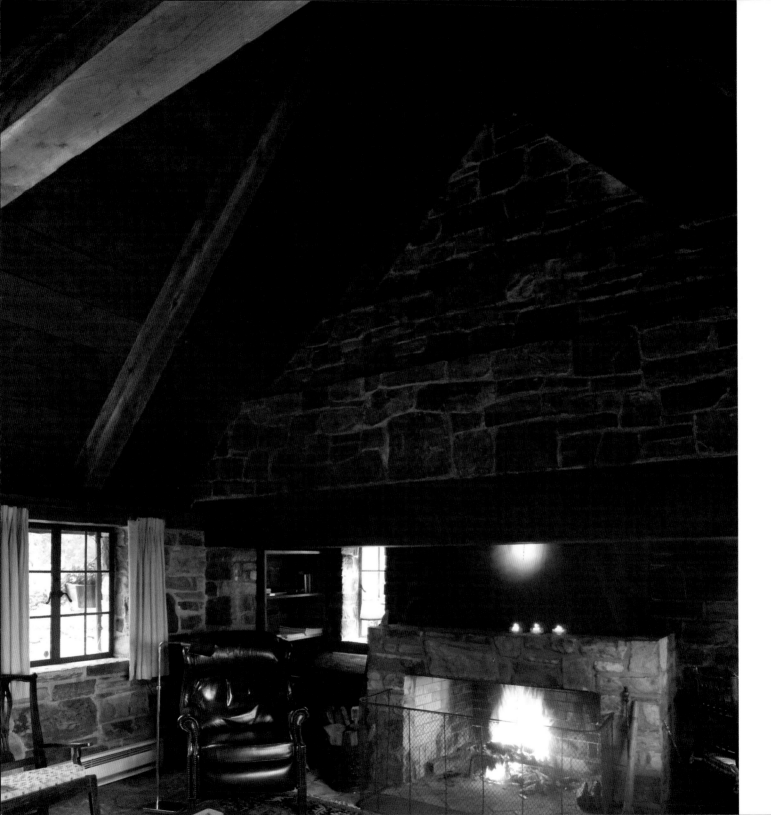

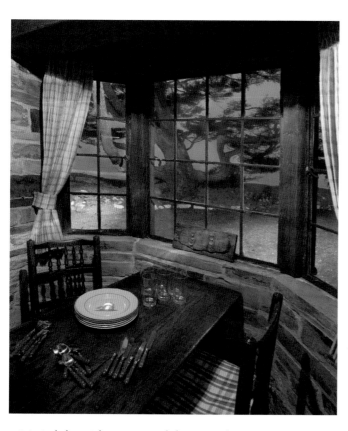

Dining in the bay window, one can watch the evening colors.

◄ *Tiered stone work above the fireplace is a hieroglyph of stone-mason methodology.*

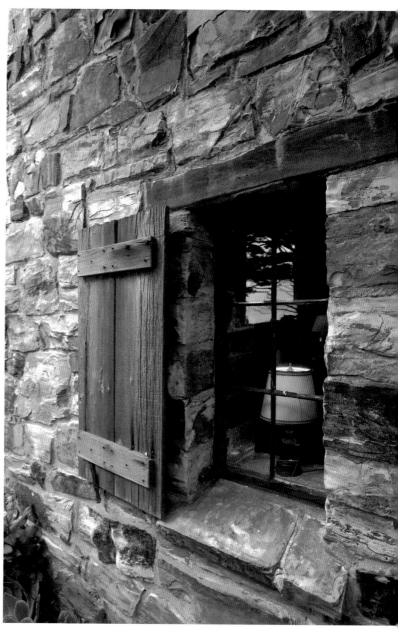

There is always a welcoming light in the window.

Stair to beach

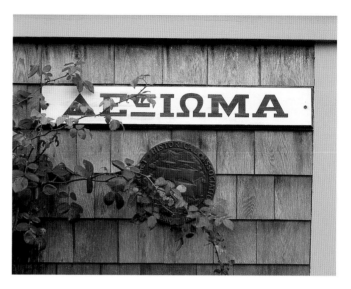

Dexioma Cottage

OWNERS: Mary and George Williams

ARCHITECT: Vernacular

PHOTOGRAPHER: Cary Hazlegrove

MARY WILLIAMS saw Dexioma for the first time when she was a girl of thirteen. Vacationing on Nantucket (the island was originally called Natocket, meaning, "the land far out at sea"[1]), she thought that the cottage was a kind of fraternity house because young men in sporting clothes populated the village, and, of course, the Greek name was painted on a shingle attached to the cottage. Five years ago, Mary was looking for a smaller summer place when she learned that Dexioma was available. She remembered the rose-covered cottage, so she sold her large, seven-bedroom ship's captain's house on the Cape, which was almost an equal trade for the tiny place in 'Sconset.

Dexioma is one of the early whale houses in the village of Siasconset, a name thought to be derived from the Native American *missi-askon-sett*, meaning, "near the great whale bone."[2] Maritime adventure was the underpinning of life in early Massachusetts. It is easy to think that when sea captains and whaling men spent time on land, they would build large houses as an antidote to the confinement of ship's quarters on long voyages. But not so in the whaling village of Siasconset, where seamens' homes took the shape of small shelters. Tidy little house follows tidy little house, each with a small front yard framed by a painted white slat, zig-zag, or picket fence. The lovely, early eighteenth-century rose-covered Dexioma is among them:

One of the most perfect gems of all the 'Sconset whale houses, is Dexioma, from the Greek . . . meaning "a place of welcome" or as it is known today, the "Friendship House."[3]

Small, timber-framed rectangular shelters—the posts, beams, and rafters of which were mortised and tenoned together to withstand the force of storms—were the mainstay quarters on land for a six-man boat's crew, where they were packed in like sardines. In true vernacular style, the cottage consisted of one central room, called the "great room," measuring roughly eleven feet by thirteen feet. It was divided by partitions of wood panel, textiles, drapes, or, on one known occasion, a leather curtain, to create "staterooms" or "cabins." Hanging lofts, a space above a very small portion of the great room, completed the sleeping quarters for the tight-fitting interior spaces. The lofts were reached by crude, steep steps, similar to those found on the companionways of small schooners.

The south portion of Dexioma is the original cabin, which comprised a small Great Hall and twin staterooms.[4]

The shed door opens under the falling roses.

Mary pitched in to set the cottage right. Daylight was coming through the shingles in the boathouse, and the cottage itself had not had many changes in its almost two-hundred-year existence. Its past owners had all cared about the oldness of the place and had not changed anything that was original to the structure. Mary did little to change any of the old parts of the cottage. She discovered a round cobblestone pantry hidden under a trap door and restored it; she did open up the kitchen and sitting areas. She had the chimney inspected and found it to be in perfect condition, and finally, to get her sleeping quarters squared away, she asked a carpenter to cut seven inches from a favorite antique bed so that it would fit into one of the staterooms or cabins. Outside, the unused dory boathouse had the daylight sealed out, and in an innovative gesture, Mary converted it into a provocative period kitchen and patio with a lovely arbor.

For Mary and George, spending time at Dexioma is less about the cottage itself than it is about living the village life. She laughingly tells of George's friends, standing outside in the early morning and calling his name from the street, as kids do, to get ready for a morning of bass fishing. Village life is the story of being outside, talking and eating with neighbors, getting your messages at the post office, and trading news. Mary has furnished the cottage with objects that have been with her in other places in her life, even if it is only a corner of a tablecloth or one of a pair of beds. Her garden glows with foxgloves and hollyhocks, along with the roses. And George's patio is a place where he and guests unwind. It is a place of welcome: the Friendship House.

1. Henry Chandlee Forman, *Early Nantucket and its Whale Houses* (Hastings House: New York), 1966, 1

2. Ibid., 8.

3. Ibid., 153.

4. Ibid., 153.

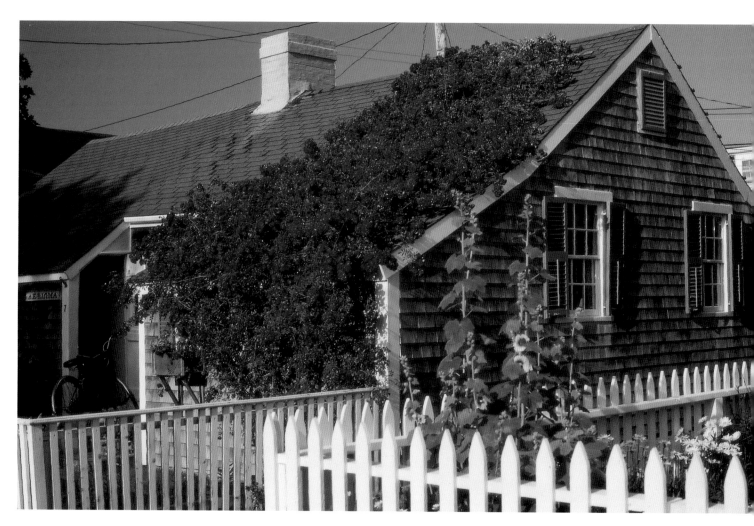

The whaling cottage bears a flurry of roses each year.

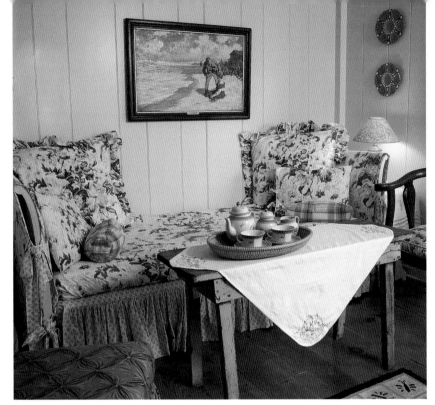

An alcove for a guest and tea

The diminutive painted cabinet, lace curtains, and pebble floor complement the sea breeze.

Soft colors and painted furnishings are all small treasures.

An unused boathouse was converted into the cottage kitchen.

New England Island House

ARCHITECT: Mark Simon, FAIA,
Mahdad Saniee, AIA, RIBA,
Centerbrook Architects and Planners, Centerbrook,
Connecticut

PHOTOGRAPHER: Langdon Clay

1 DRIVEWAY
2 DECK
3 MARSH
4 COVE
5 PONDS
SITE PLAN

THIS ATTRACTIVE yet reserved vacation house borders a beautifully natural, marshy wetland and is surrounded by wildflowers, deep emerald foliage, and tendrils of vetch. Two acres of grassland are home to a wonderful assortment of birds and wildlife. The marshlands outline a rocky shoreline along a small bay; the sea lies beyond. The area is well known for its sailing and fishing, and this family has a love for the island and its maritime focus. They wouldn't miss a chance to get away, if only to watch the boats in the bay, do a little sunbathing, and relax for an unhurried reading of the Sunday papers.

To satisfy the owners' request for a symmetrical house clad in cedar shingles, the architect drew on features from English cottages, stick and shingle cottages, Japanese houses, a bit of Sir Edwin Lutyens, and a dash of Bernard Maybeck. The result is a unique and robust, yet enticingly graceful cottage. A wide door at the top of generous steps forms the central entrance. The door opens to a small octagonal vestibule with an inlay of a maritime compass in the floor of the foyer. The main interior spaces and a large deck lie beyond. Views are framed and highlighted from a variety of focal points to reveal the ever-changing and unique perspectives of island life and seasons. Upstairs, the master bedroom offers water views from large dormers and the balcony. Ceilings in the upper rooms are examples of grace and complexity, with unusual configurations forming at the intersections of hip roof and dormer.

The wide, open deck is bordered with continuous seating and is partially sheltered under the roof's overhangs. Because of the substantial protective overhangs, the architects were able to design a very glassy house that allows the cooling southwest breezes to enter, yet protects against occasional fierce winds and rain. Windows in walls and bays are staggered along the first-floor level, where the living and dining rooms are, to the second floor, where there are three bedrooms, giving the house an overall sense of a syncopated rhythm. The informal deck seating rises above large boulders that were excavated at the site and moved to serve as rip-rap protection for the cottage's substructure and basement. Views of the sea are a focus for the design, and enjoying them is a part of spending time on the large deck or the screened porch.

The cottage is sited well back from the beach and the marshy wetlands. ▶

French doors and floor-to-ceiling windows surround the sunroom. Outside, a broad deck is furnished with a border of continuous seating.

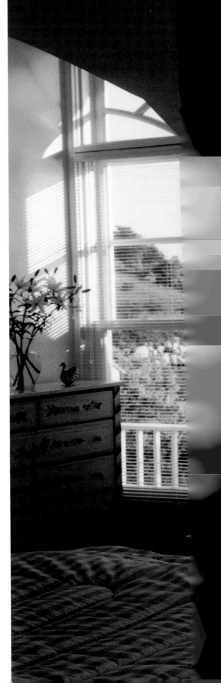

Shoreline and water views are framed by large dormers inset with arched windows.

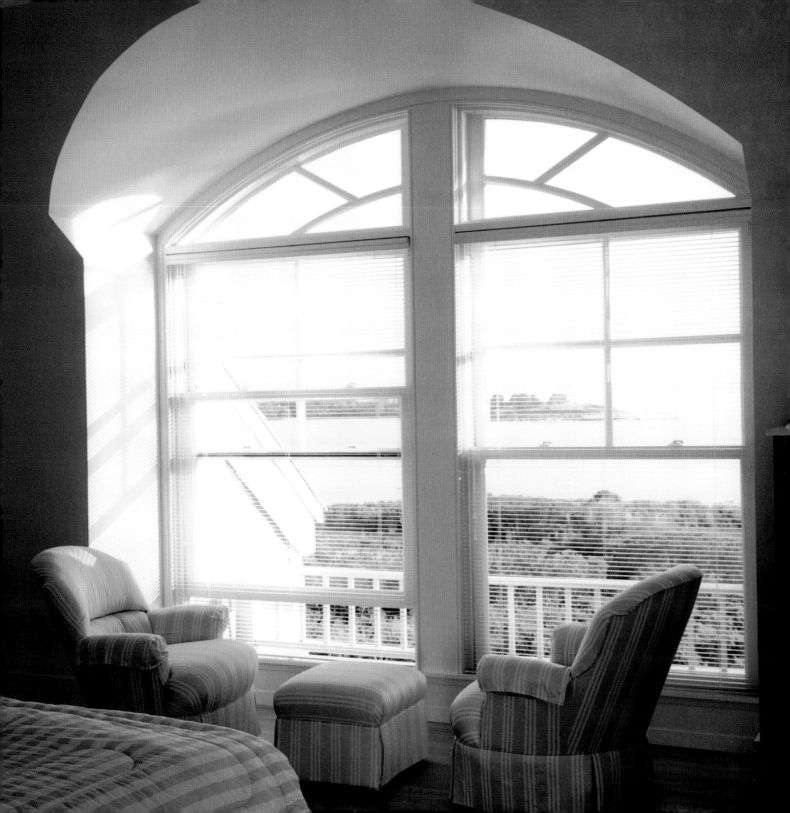

Collective imaginations created an octagonal foyer representing the complex cottage orientation.

A spherical light fixture and window seat at the stair landing are subtle references to maritime life.

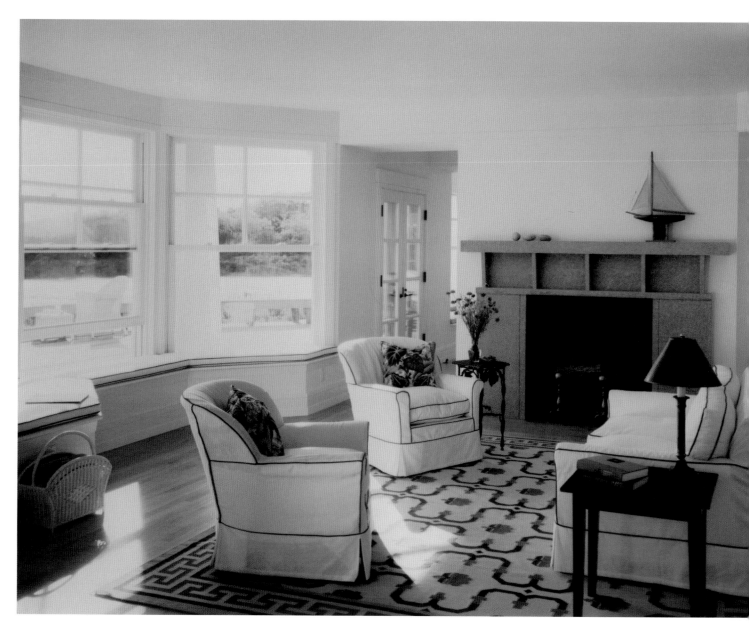

Slipcovers reminiscent of officers' "whites" create a stately informality in the living room.

Behind a grape stake fence, along a stone walk,
under an old oak tree is a quintessential seaside cottage.

Fair Harbor in Carmel

BUILDER: M. J. Murphy

PHOTOGRAPHER: Steve Keating

STONE, BOARD, AND BATTEN, and small shingle-style cottages are typical of the coastal communities that evolve on the oceans and gulf coasts. Carmel is a demure community; a walk along the dappled, tree-covered streets is an introduction to an unpretentious sensibility. It was part frontier and part euphoria when designed to become a dream in the making. The 1902 Carmel Development Company sales brochure was addressed "To the School Teachers of California and other Brain Workers at Indoor Employment" in the belief that they were most in need of a "breath of fresh air." Developers designed the lot sizes to be small and affordable. The little village attracted beguiling, well-educated world travelers, as well as painters, poets, and actors. George Sterling, the early-twentieth-century poet wrote: "Carmel was the only place fit to live—it was the chosen land."

M. J. Murphy was one of the first of the beloved Carmel builders. He built Fair Harbor in 1927 on two of the small Carmel lots. The cottage was a small twenty-by-thirty-six-foot rectangle, built for a total cost of $3,300. The new owners, who purchased it in 1975, updated the cottage in 1994.

Fair Harbor is the exemplar Carmel cottage, lodged in the oaks on a lovely shady corner where the street jogs to the right before continuing down to the beach paths. Under the

oaks, a cobblestone sidewalk is skirted by a crooked grape stake fence that is a traditional style in the one square mile of Carmel-by-the-Sea. Inside the grape stake fence, a small stone path leads to a stone courtyard, where flowers flank a Dutch door entry on one wing of the cottage, and a brick chimney accentuates the steep pitch of the three peaks of the roof on the kitchen wing. Shuttered windows and window boxes of hydrangeas perfect the exterior.

The interior is a collection of elegant open spaces. The ceilings show open studs in vaulted spaces that mirror the inside dimensions of the roof's steep pitch. A white and gleaming pristine simplicity speaks of nothing more than privacy, peace, and promise.

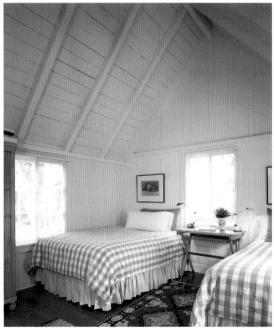

Small bedroom facing courtyard.

The stone courtyard between the dining area and the bedrooms are where potted geraniums bloom.

The benefits of a steeply pitched roof are evident: A vaulted ceiling, with open studs and bright interiors keep the spirit joyful. ▶

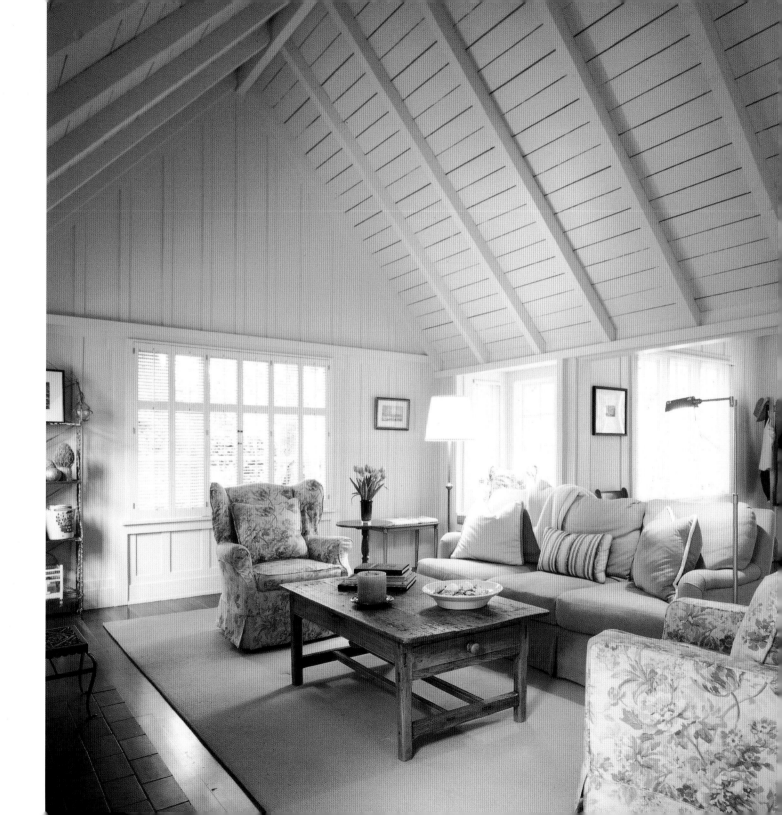

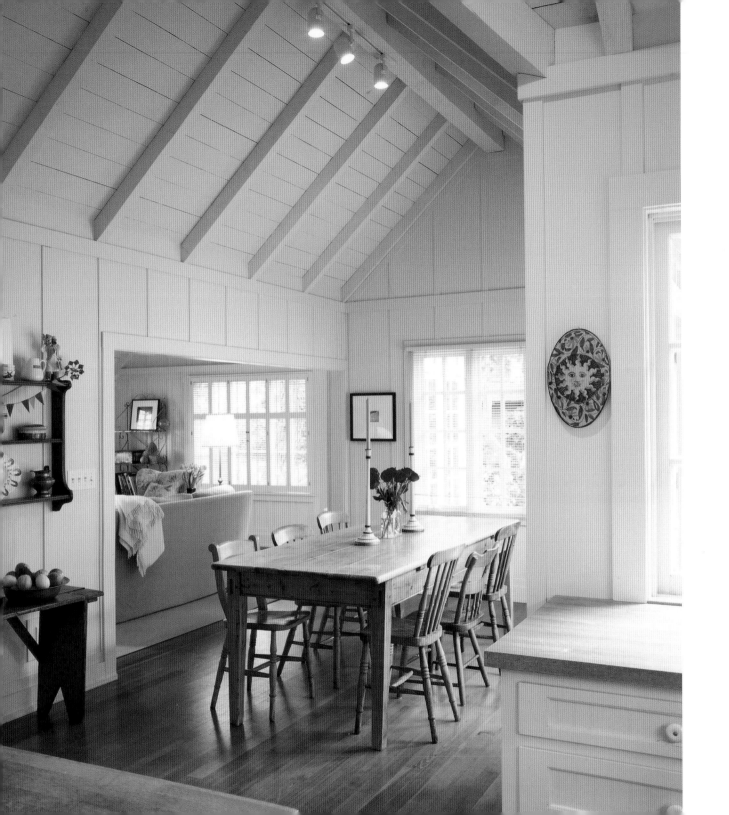

*Board and batten walls add an element of comfort
to the cozy furnishings of the living room.* ▶

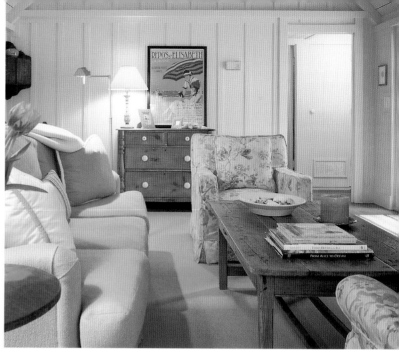

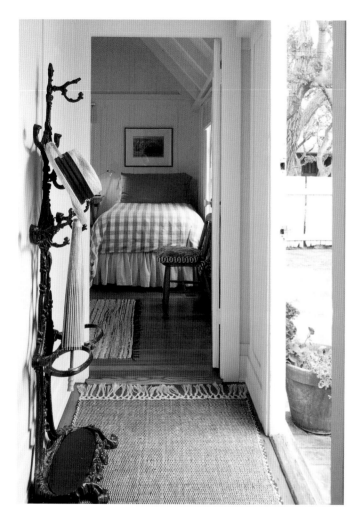

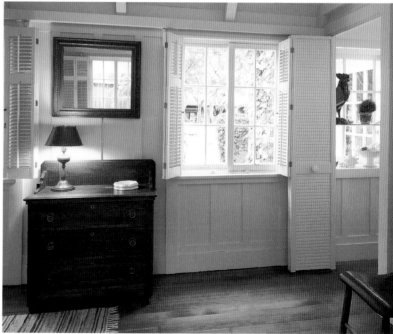

*The entrance through a Dutch door from the stone covered courtyard
is convenient to the bedrooms.*

◀ *The large wood table, board and batten walls, and wood flooring and countertops
warm the dining area which is flooded with sunlight.*

*Cottage life requires a delicate balance of light and heavy to offset foggy days.
Fair Harbor is a perfect example.*

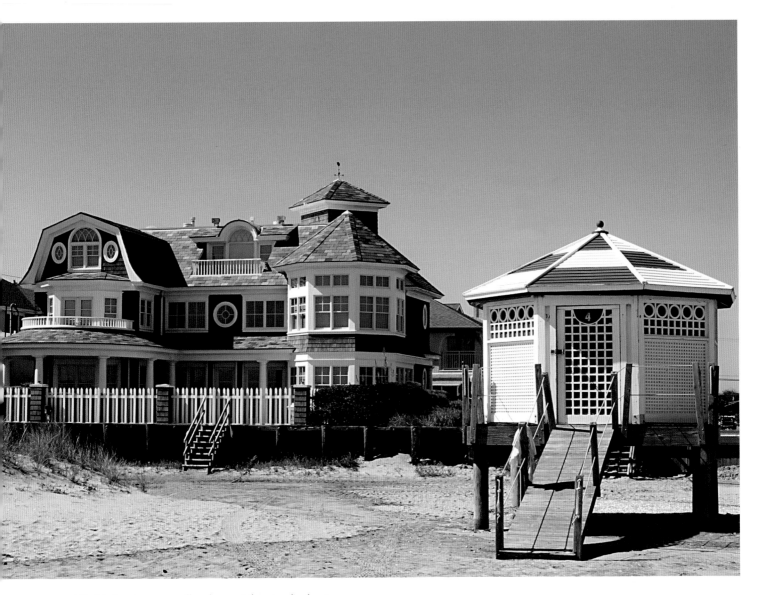

The shingle style cottage recalls early-twentieth-century beach cottage styles. A public safety life guard station designed to match was donated to the City by the Newmans.

Shingle Style at Margate

OWNERS: Bud and Judy Newman

ARCHITECT: Robert A. Johnson, The Johnson Group, Margate, New Jersey

PHOTOGRAPHER: John DiMaio

THE NEWMANS of Philadelphia learned of a lovely oceanfront lot on Absecon Island and had visions of a classic shingle-style cottage for relaxed seashore trips and holidays. The Newmans are a testament to the vision of Dr. Jonathan Pitney, the nineteenth-century founder and developer of the island. When Pitney's partner, railroad scion Samuel Richards, saw Absecon for the first time in 1852, he was horrified; "the island appeared uninviting . . . its sterile sand heaps, naked in their desolation, gave it a weird, wild look, a veritable desert." But Pitney had faith that a solid community would be built here, and the island began its life as a sand-covered health resort and bathing village—where the cost of an acre was $7.50 in 1854, on average.

One hundred and fifty years of oceanside pleasure has seasoned this community well. The shingle-style cottage designed for the Newmans recalls traditions of summers on the shore. The architect's use of gambrel, arched-eyebrow, circular, and turreted roof forms, as well as oriel and square windows adjoining or above outdoor balconies, creates a vision of the turn of the nineteenth century.

The interiors are designed for a relaxed and fun-filled seashore lifestyle. The floor plan is open with areas defined by columns, varying ceiling heights, and changes in floor levels. The living areas are designed to flow into the outdoor gardens. An open second-floor balcony surrounds the two-story living room and emphasizes the spaciousness of the central living area. The curving stairway is a sculptural relief from the angles of the bay windows, and it ascends to the third floor, which is devoted to the master suite.

Along the beach at frequent intervals, there are lifeguard stations for public safety. Mr. Newman asked Mr. Johnson, his architect, to design a station that was compatible with the design of his cottage. The architect incorporated a design element from the corner of the cottage into the nearby lifeguard station. Mr. Newman has, in a generous fashion, donated the lifeguard station to the city and its beach citizens.

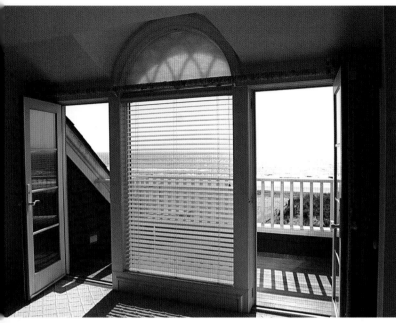

◄ *High, upper-story doors open onto a small balcony for privacy and ocean watching.*

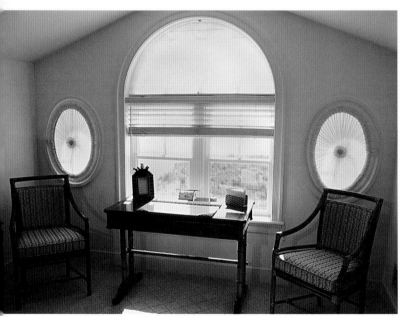

Oeil-de-boeuf windows on either side of the arched window give light and personality to the guest room under a cottage-style gambrel roof.

Circular forms in windows, gates, columns, and tetra-style porticos soften the architecture.

A sculptural staircase descends through three floors, connecting the open two-storied living room to the upper levels.

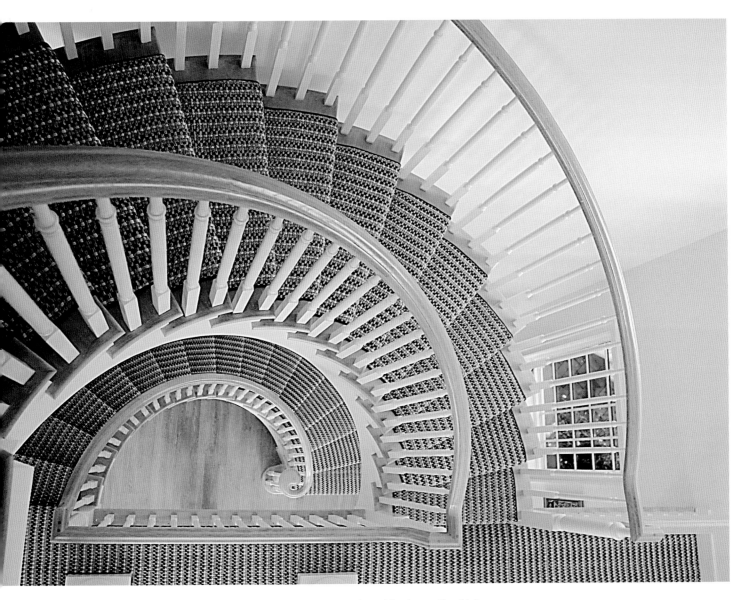

A nautilus staircase connects three levels of the cottage and inspires the comfort and familiarity of beach life.

The spiral stair tumbles into the living room from above. The Newmans' collection of folk art and furnishings capture the spirit of the beach.

where dreams come true

Poet George Sterling loved the sting of the surf against his body . . . and the personal pleasure of time on the black granite beach boulders.

Sunlight floods the entry. Zinc cabinets are embedded in the wall six inches deep. The tutoring room is behind the entry; living room is in the foreground.

*A flower-laden circular arbor above the garden gate
is a preview of the lushness of the grounds.*

Connie Umberger's Cottage

OWNER: Connie Umberger

ARCHITECT: Barn and Shed Vernacular

PHOTOGRAPHER: Cary Hazlegrove

CONNIE UMBERGER'S EXPLANATION of the individuality and distinctiveness of her cottage can be very perplexing. "Some won't come here," she sighs, "it's too crude, too shabby." By her own description, when she first saw the Nantucket property, it was, she recalls, "a flat, shrubless, treeless, shapeless barnyard . . .with an existing house and a barn standing on it." An educator from a long line of men and women who saved everything in trunks, attics, and cellars, Connie houses a collection, if not an archive, of precious family treasures in her cottage.

No one would think of Connie's pilgrimage to Nantucket as part of a plan to fulfill a lifelong dream. Hers was a journey of extraction; a mutiny of the past. Her courage was embodied in the persistence of her youngest daughter, and together they explored Nantucket Island, one of the places where they found a warm familiarity. Connie looked at the barn and envisioned a seaside cottage for herself and her daughter. She began converting the old horse barn using very little money. She found old doors and windows and hired help to install them. The "lean-to" attic roof was raised, and the upstairs was turned into two rooms for additional space. To the right of the main entry was her small tutoring room. The first-floor living room and kitchen were separated by only the kitchen island. Progress was slow as she managed to work on both making a new life and a new cottage.

When Connie came to Nantucket, her life had changed dramatically—so much so that for the first couple of years she found it difficult to focus her attention on music or even on reading. In time, she grasped one end of a shovel, put her foot on the other end, and pushed. She dug and planted; she didn't need to concentrate. In the ground, in flower boxes around the old shed, she laid brick pathways and stone walks and raised succulents, irises, poppies, roses, and trees. The garden and the cottage began to flourish. The American Horticultural Society visited the garden; its wonder inspires others. Connie's cottage and garden are remarkable in that "it didn't take a lot of money, it didn't take knowing anyone, it only took trying to keep going forward," said Connie. Too "shabby and crude?" It couldn't be more elegant.

A home in Nantucket holds a lifetime of treasures. The half-arched windows were discovered by Connie, who had them installed to frame the furnishings.

◄ The garden is a work in progress, a place for thoughts, moments, and doings.

Books are arranged by subject; this room holds History.

Connie's grandfather made this dollhouse when he was a young boy, ca. 1890.

Collections and fragments gather on an entry table.

Non-fiction books are arranged in the living room.
The portrait over the fireplace is Connie's father.

This cottage was built by photographer Arnold Genthe in 1905.

Vannelli/Genthe Cottage

OWNERS: Vince and Dana Vannelli

DESIGNER: Arnold Genthe

PHOTOGRAPHERS: Michael Mathers; Jon Schink

ON SEACOASTS there are legends of discovery, such as the story of Arnold Genthe, a twentieth-century scholar and philologist. Born in Germany, Genthe was raised to follow his father and uncle's fame. They were both scholars; his uncle held the Kant Chair in philosophy at the University of Tübingen. Arnold left Germany to become a tutor to a young man in San Francisco. While there, he met the bohemian group of painters and writers that surrounded poet George Sterling. Together they, and later others of the group, settled in Carmel, where Genthe built his dream cottage:

I drew up the plans myself. The sloping roof, following the lines of the distant hills, was shadowed by two great pine trees, the largest in Carmel, and was supported by four large redwood trunks, with the bark left on. A wide porch looked out on the sea. The spacious studio and living room, thirty by sixty feet, with a high ceiling and two sky-lights, was built entirely of redwood, the rafters being not box beams, but solid redwood. My particular pride was the fireplace, which was large enough to take four-foot logs. And there was a cellar—solidly built of cement.[1]

And it was a very special cellar. There, Genthe made his first experiments with color film and processing. His inspiration, he loved to say, was the ever-changing color of the shadows of the dunes and the Carmel sunsets.

The Vannellis live outside of San Francisco, and the two-hour trip to the cottage is perfect for a weekend with their three children and friends. They often stay during special holidays and enjoy extended visits during their summers. Fascinated by the cottage history and the story of Arnold Genthe, they were particularly attracted to the cottage's large stone fireplace—the pride of Genthe's labors. The old wood floors glow with a patina of warmth and relaxation. The family loves to gather outside by the fireplace for quiet and peaceful evenings, and to listen to the sounds of the ocean waves rushing in during high tide. The Vannellis were fortunate enough to benefit from the work of Elizabeth Webster and Jon Schink. They, with the help of a historical architecture firm, spent 1999 to 2000 dedicated to the meticulous renovation of the cottage, which had fallen into

serious disrepair. They wrote, "As the [Vannellis] have contributed their personality and style . . . so did the artists, photographers, and writers from eras past. We've all left our touch on the colorful history of the Genthe House." Carmel is very fortunate that this cottage has been so lovingly and thoughtfully restored to its original state. It is a treasure in California's cultural and historical pantheon.

The wide expanse of the porch was a gathering place for artists, musicians, and philologists.

The interiors have been restored to the pristine condition of the original cottage. Woodwork, brickwork, and windows were meticulously reinstated. Ironwork was used to add height to balcony railings.

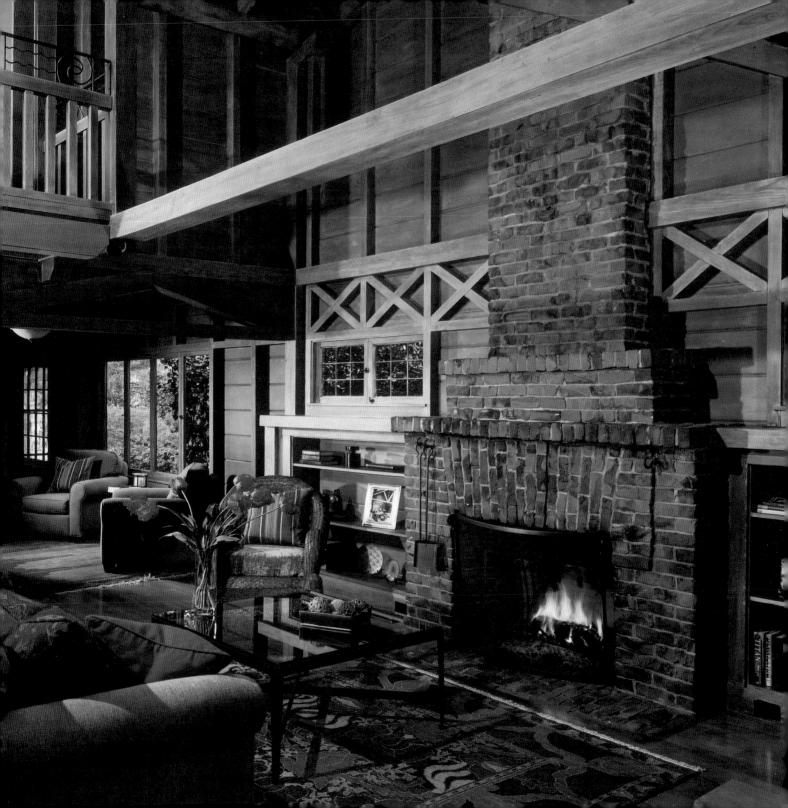

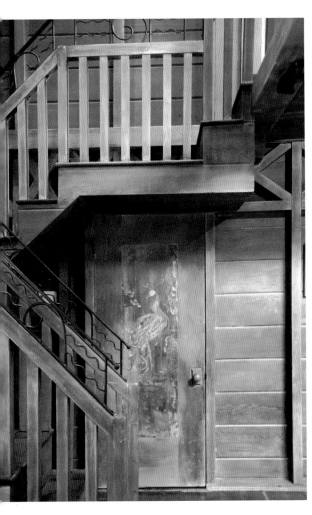

The painting of peacock is a treasured relic. The door and painting were both restored.

Original redwood timbers and designs by Genthe enclose the stairs and landing leading to the upper level bedroom.

The upper level balcony looks over the living room, with sliding
shoji-style doors opening to the bedroom. A skylight adds
natural light to the balcony.

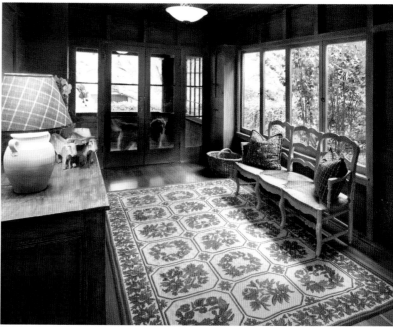

The entry vestibule between the exterior porch and living room
offers a warm welcome to the cottage.

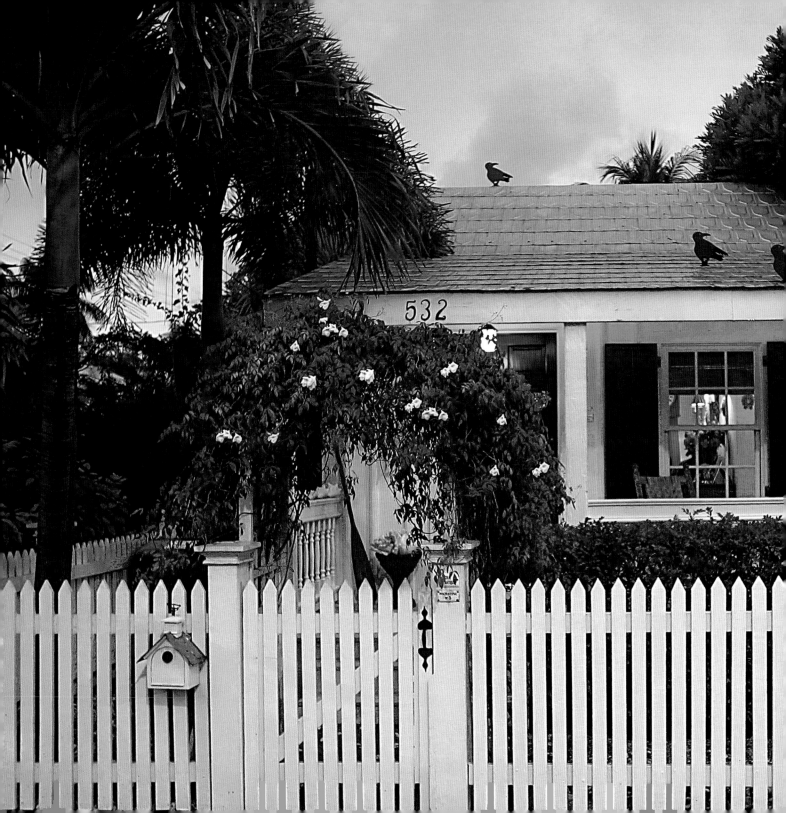

*The owner saved this vintage cottage from ruin
and brought it back to life as Key West's best example
of early vernacular architecture.*

Treasure Cottage

OWNER: Michael Pelkey

ARCHITECT/DESIGNER: Vernacular; Michael Pelkey
Interior Design

PHOTOGRAPHER: John DiMaio

MICHAEL PELKEY is a person who knows how to pull things together for a perfect reward. In the Conch Republic of Key West, Michael discovered a 1906 cottage formerly occupied by hunters and cigar makers and saved it from complete disrepair in the nick of time. Michael bought the five-hundred-square-foot cottage about ten years ago, while he was working as a personal chef and making frequent trips to Europe. He took advantage of his time in London and Paris to shop and look for antiques and his other favorite objects: ironstone and black basalt ware.

Vine-covered and gated arbors open into the tidy thirty-by-fifty-foot piece of property. Nearly every inch of the cottage was rebuilt and restored by Michael with help from his brother, Larry, a contractor. Michael's designs and plans were faithfully carried out. The major floor plan was for four rooms in the tiny space, each measuring only ten feet by eleven feet. Floor-to-ceiling cabinetry and a wonderfully unique double set of window seats with bistro tables give the rooms an added sense of spaciousness. Michael incorporated antique arched windows wherever possible above cabinetry that represents his devotion to his culinary past. The windows are also found in the guest house, above the front door, and above the bed.

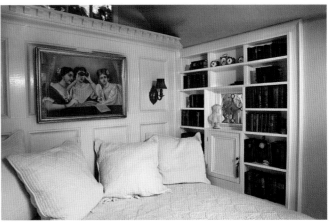

The compact guesthouse features an arched window above the bed and a square window set into the bookcase for natural light. The precious pastel "peepers" hang above the bed.

Double sets of French doors open onto the spacious deck, where a guest cottage sits.

This birdhouse, built by Larry Pelkey, is a replica of the guesthouse. Larry was the contractor for the restoration.

This subtle touch adds dimension, elegance, and light to all of the interior spaces. Another of Michael's favorite features is the old wood flooring, which adds softness to the interior. The pattern was set at random using three- to ten-inch pieces of Savannah heart pine. A large front porch, with its four columns, covered by a tin roof and shuttered windows, completes the stylish openness of the cottage.

Devoted to the community of Key West, Michael loves to entertain and loves to cook, of course. He has designed a picturesque pergola and picketed deck, thirteen feet wide and thirty feet across. Two sets of French doors open onto the deck from the interior. One set of doors opens onto the dining area with seating enough for ten. The center area of the outdoor space is furnished with wicker and potted plants. At the opposite end of the deck is the guesthouse, another jewel in this Key West heaven. A paned glass door with another antique glass arched window above opens into the guest quarters. The entire deck area is surrounded by lush plantings that occasionally reach over the railing. Michael's talent for simplicity, economy, and more than a few brush strokes of genius, blossomed into this dream-come-true cottage.

Michael created a spacious thirty by thirteen foot deck for his second loves, cooking and entertaining.

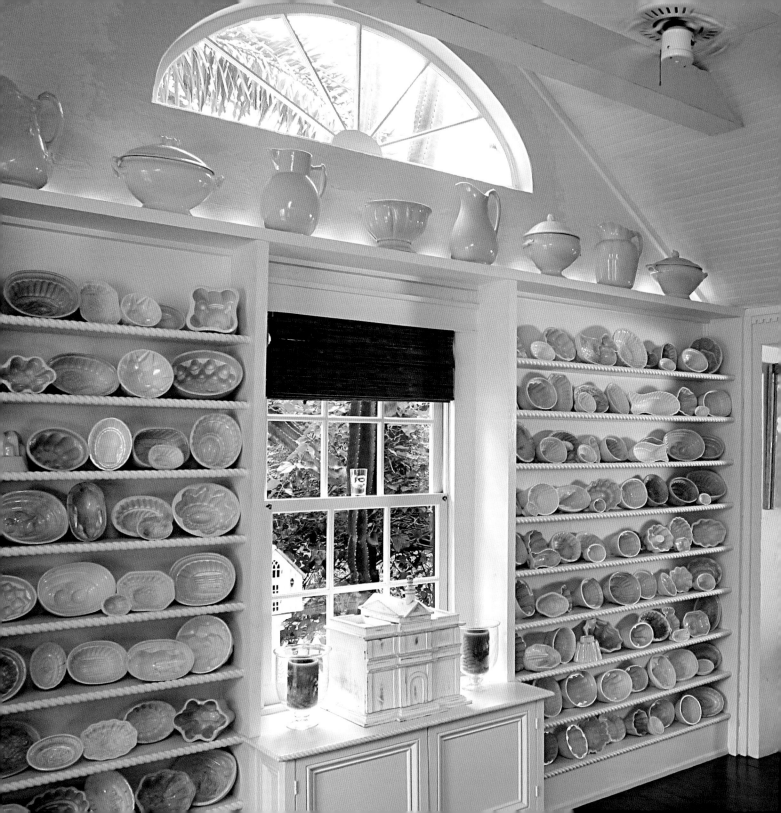

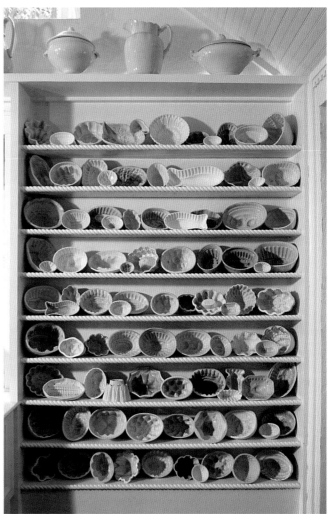

Unlimited shapes and patterns in subtle tones

The wall opposite the living room area is a part of a larger collection of pudding molds. The soft colors add dimension to the space. Two bistro-style tables and window seats economize on space without giving up individuality.

The large front porch is a semi-public place where neighbors can be greeted on their evening strolls.

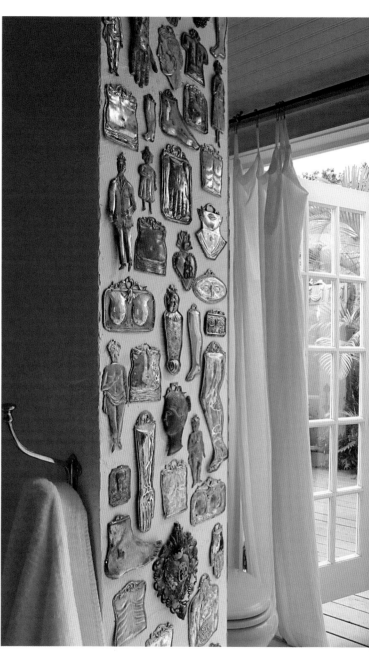

A collection of ex votos, or devotional pieces made by Italian silversmiths, hangs in the bathroom. They are believed to heal the part of the body they are designed to represent, such as arm, leg, or heart.

The bistro-bay dining setting easily doubles as a breakfast nook.

Tennessee Williams's Cottage

ARCHITECT: Vernacular

PHOTOGRAPHER: John DiMaio

The swimming pool at the back of the cottage was built by Tennessee Williams. A mosaic rose on the floor of the pool signifies his love for his sister, Rose.

FOUR YEARS AGO, while visiting the Florida Keys, a lucky couple had a friend who wanted to show them a wonderful little cottage on Key West. It was white with red shutters and was surrounded by a picket fence, a flurry of roses, palms, a Madrona, and a few other deciduous trees. It sat on a corner facing Duncan Street. Once inside, and captivated with the rarity of the place, the husband burst out, "we'll take it!," surprising his wife, who hadn't realized they'd been looking for a cottage. What they had discovered was the original Key West cottage of Tennessee Williams.

Just the mention of Tennessee Williams causes poetic visions to glow with an essence as mystifying as the lightning bugs that inspired magic in the hearts of young Tennessee and his beloved sister, Rose. Throughout Williams's long and troubled life, which even he described as "apocalyptic . . . registering at least eight points on the Richter scale," he was still a man who worked ferociously every day: up at 5 a.m., at his desk for three or four hours, then a swim and breakfast— before the day began to unravel around one o'clock in the afternoon. He wrote and swam every day, wherever he was. And luckily, in the midst of his apocalypse, he found this little cottage in Key West around 1950. It was a small Bahamian house that he bought from the local florist—the same white cottage, with red shutters and a white picket fence. The property had room enough to eventually build a writing

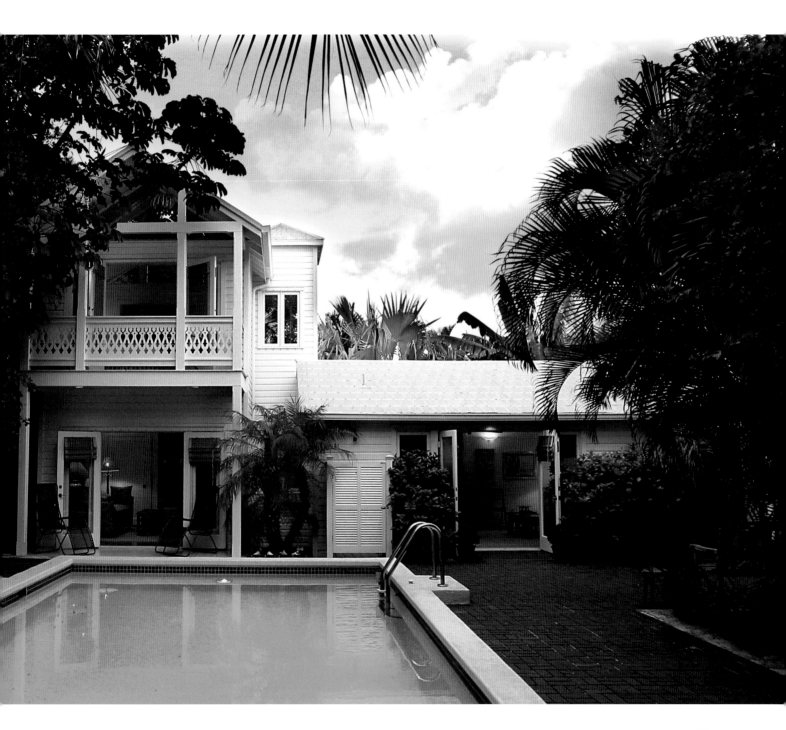

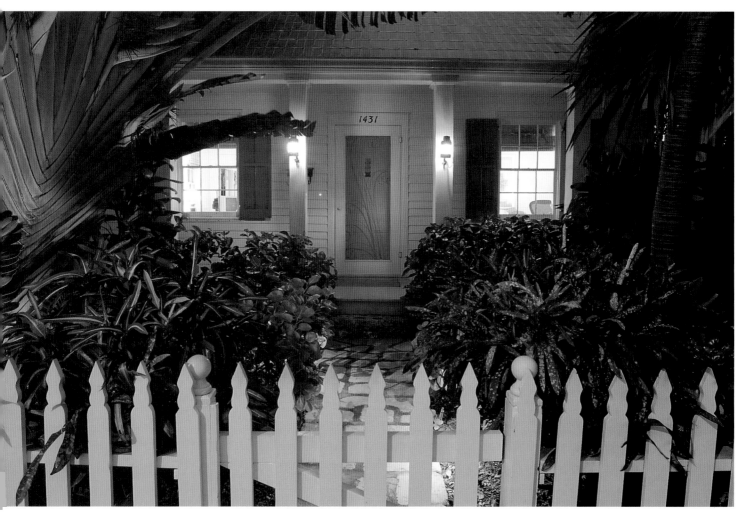

studio, a gazebo, and a small swimming pool. Williams arranged a public groundbreaking ceremony for the gazebo, and small garden—the Jane Bowles Summer House—in 1970. In accord with his affinity for everything associated with a rose, Key West rock roses were planted immediately following the groundbreaking.

Williams loved the Key West life, in part because of the happiness it gave his grandfather, who lived there with him. They both returned to its reassurances during the countless

The corner cottage looks the same today as it did when Tennessee lived there, with the same screen door on the front.

days of Tennessee's eternal restlessness. Island life offered orderliness and comfort for him for many years. Today, the little cottage is well cared for and offers a respite for its new owners as well. Once the hurricane season passes, and the weather turns cold up north, the new owners of the Duncan Street cottage settle in for the island life until spring.

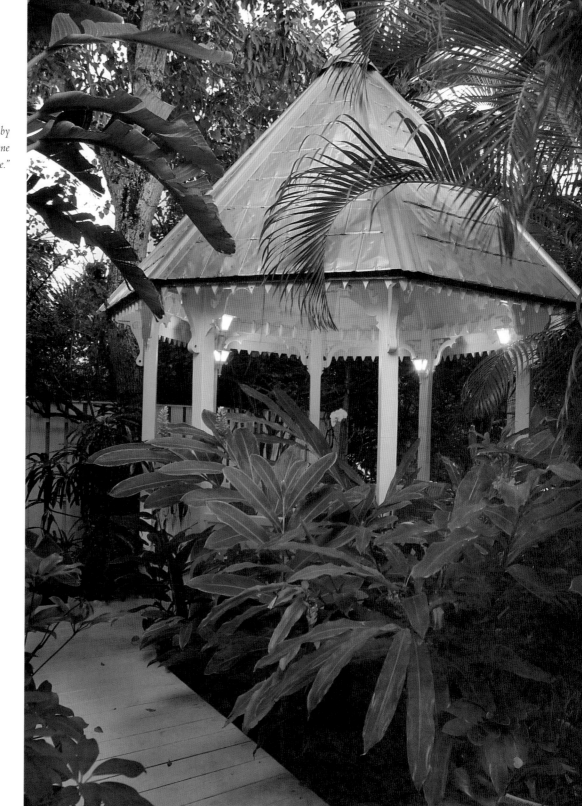

The tropical gazebo was also built by Tennessee, which he named the "Jane Bowles Summer House."

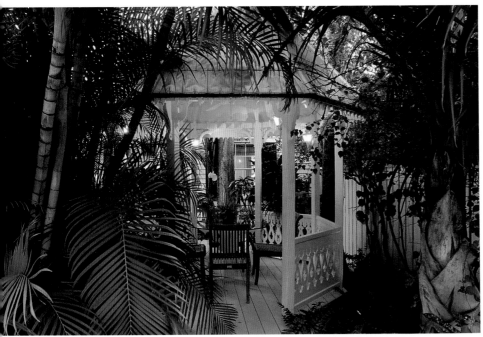

View of the furnished gazebo

Williams's devotion to his sister Rose was a rare thread of continuity in his life.

The swimming pool beyond the sheltered gazebo

French doors open to patio

OVERLEAF: *Life in a small cottage expands to accommodate the owner's needs; indoor and outdoor life become one.*

A stained glass window above the kitchen area

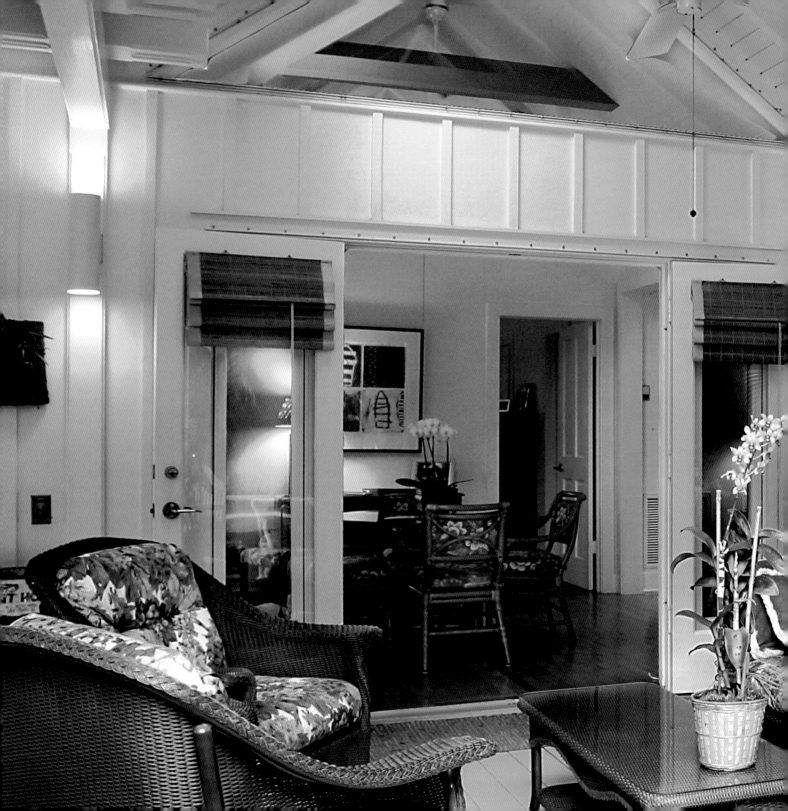

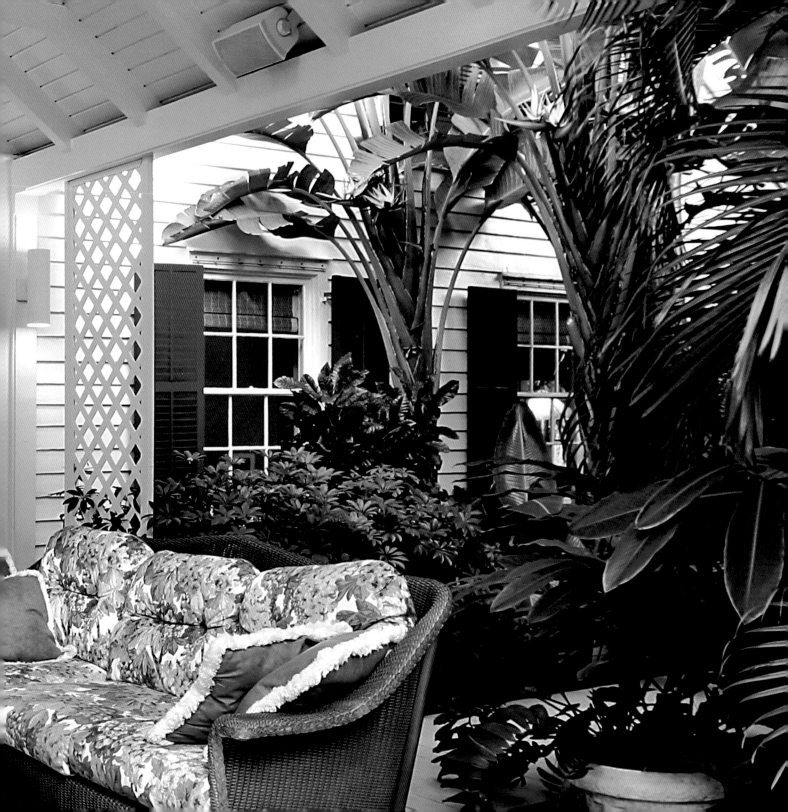

Brunswick Cottage

OWNER: Fran Rue

ARCHITECT: Vernacular

PHOTOGRAPHER: Richard Leo Johnson

A corner of the large, broad porch is a place for dreaming.

BRUNSWICK sits halfway between Savannah, Georgia, and Jacksonville, Florida, in the middle of the Georgia coast. Once a booming port town, Brunswick is now a sleepy, slowly-being-rediscovered coastal village, with all of the vitality and variety of southern seaside village life. Fran Rue bought a little cottage in 1994, and with her two pugs, Lulu and Jet, lives in the 1890s dwelling.

Fran, who was born in the Black Banks Plantation on St. Simons Island, prefers having the sea nearby. Having grown up in Atlanta, Fran didn't take long to realize that she wanted to live closer to the coast. The soul of Black Banks is in her blood, and her affections for the gentleness and flair of

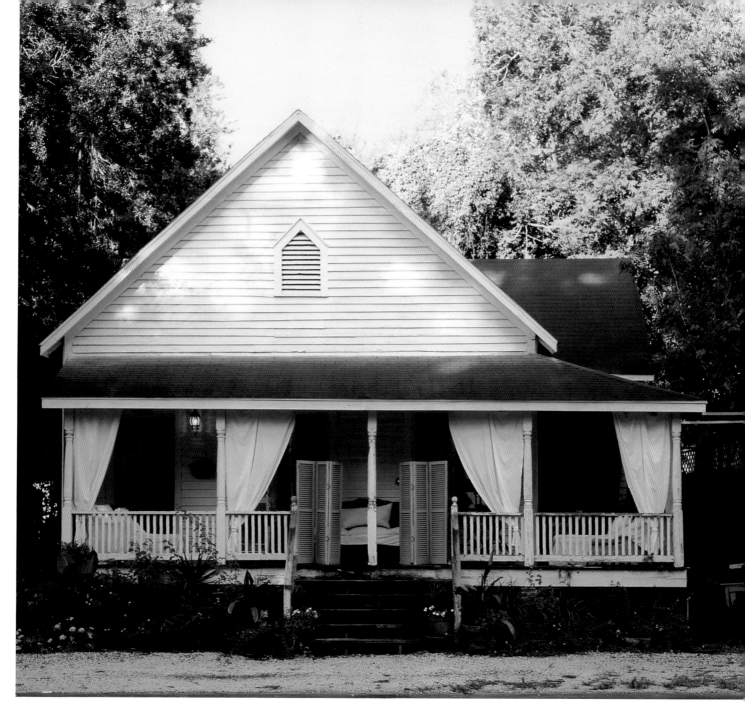

The seaside community cottage is a treasure box of at least one hundred years of local lore.

southern life are apparent in her home. The 1,500-square-foot vernacular cottage is an unerring, if ironic, reflection of the aristocratic setting of the Black Banks, a microcosm of romance and style. It features Fran's collection of treasured antiques, many of which once belonged to her grandmother and then to her mother, including furniture that came from the Plantation. Fran's interiors sound with echoes, generation upon generation, that are replicated in multiple mirrors, hallways, and nooks. Fran's love of the romantic includes a taste for New Orleans fashion: the flicker from crystal chandeliers plays against baroque frames; peeling, painted shutters frame old world roses; and chintz-covered chairs next to gold leaf tea tables and lamps with silk shades create a special chatting alcove. At every turn, there is a Southern vignette—a narrative of human emotion and penetrating romantic mannerisms. Fran's cottage tells the story of her life and offers a hint of the mysteries of the Black Banks Plantation and island life.

*The entry vestibule is furnished with a wrought iron sofa
and a cast bronze and marble table. Many of the antiques
are family heirlooms.*

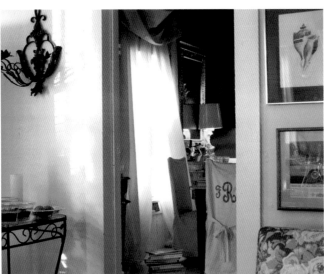

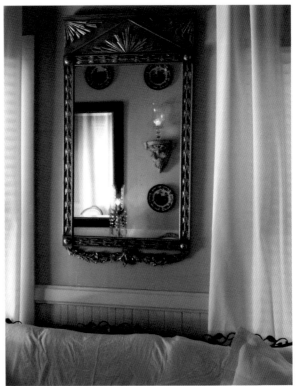

CLOCKWISE FROM TOP LEFT: *The bedroom is plush with linens, chandelier, and cherubs; The room is complemented by a portrait of Fran's mother; "…Coleman Hawkins moves the curtains…"; Mirrors are used to "mirror" one another and can set off a causal chain of memories which virtually shimmer through the cottage.*

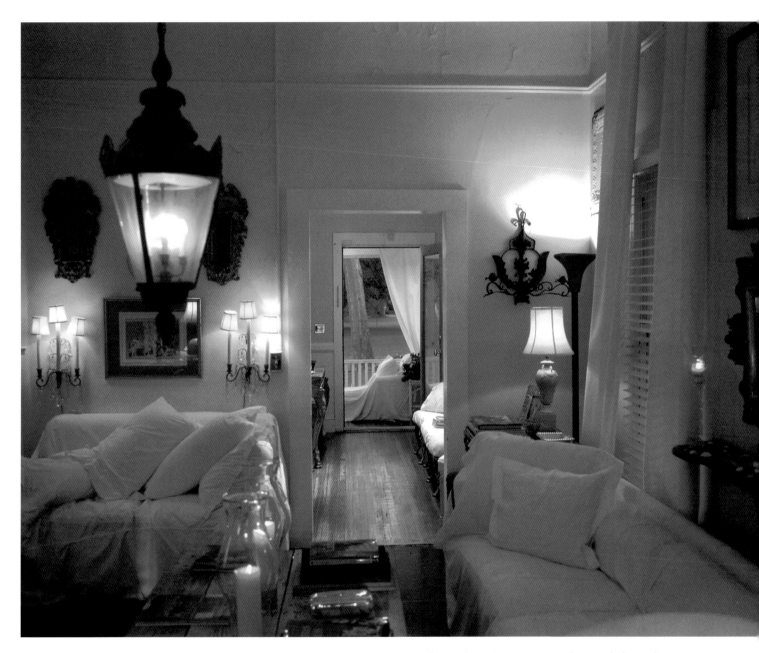

The sensuality of the South is evident at every turn. The cottage beckons with textures, colors, candles, and breezy curtains.

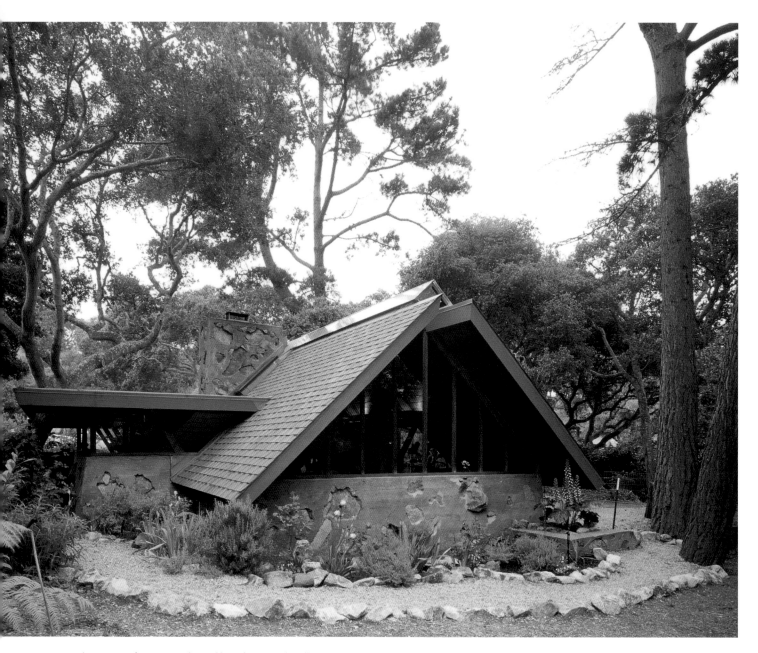

This one-story frame cottage designed by architect Mark Mills
in 1952, sits comfortably under California Oaks.

Michelle Diane's Stone Cottage

OWNER: Michelle Diane

ARCHITECT: Mark Mills

PHOTOGRAPHERS: Steve Keating; Michael Mathers

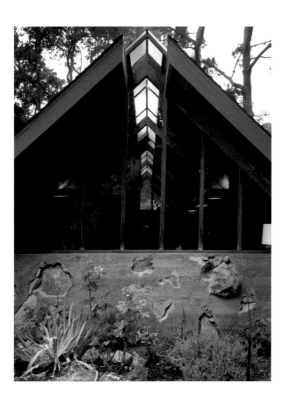

THE THRILL OF FINDING the right cottage for yourself is emotional and sensory. A stepped-up beat of the heart and a dizzying gasp of breath freezes the moment until unconditional love steps in and suddenly one cannot be separated from the object of desire. This is what Michelle Diane experienced at her first encounter with the modern, stone cottage set under a grove of sheltering California oaks. "The home moves me in a way no other has," affirms Michelle. A first glance at the cottage makes it easy to understand Michelle's powerful feelings of attraction.

The cottage is woven into Carmel's architectural lore. One of the young and innovative architects of his era, Mark Mills studied under Frank Lloyd Wright at Taliesin West. Shortly after his four-year stay there, Mills moved to Carmel and was asked by Wright to oversee the construction of the Walker House on the Carmel beachfront. While in Carmel, Mills worked on his own design commissions; Michelle's cottage was his first building in Carmel. The project was financed by Mrs. Clinton (Della) Walker, who commissioned Frank Lloyd Wright to design her unrivaled cottage on the Carmel beach, one of only three seashore designs by Wright that were ever built. Mrs. Walker's house was Wright's last design for an "Oceanside Dwelling." While Mark Mills was designing and working in Carmel, the stone cottage was built and sold to Mark Mills' father; later it became Mark Mills' own "bachelor" cottage.

The grace of the cottage in its setting is unsurpassed. It is surprising to find the Taliesin West trademark of "desert masonry" used in a seaside environment. Large pieces of Carmel stone are embedded in poured concrete walls and other structural features of the cottage. They are as perfectly suited to Carmel's sunny and occasionally moist climate as they are for use in the desert of Arizona. The cottage is a simple A-frame, which is intersected by a flat-roofed L-wing, under which is an open carport. The beams of the A-frame rest in the desert masonry walls and are supported by vertical posts that also frame fixed pane windows in the gabled ends of the roof. A mitered glass skylight runs the entire length of the roof ridge, and skylights flank the desert masonry chimney above the living room fireplace. The interior is

finished in natural redwood, and door heights are 6' 8," a scale often found in Frank Lloyd Wright designs. Mark Mills created many architectural masterpieces; this is certainly one of his best. Light pours into every room—a dream in Carmel. What more could a girl want?

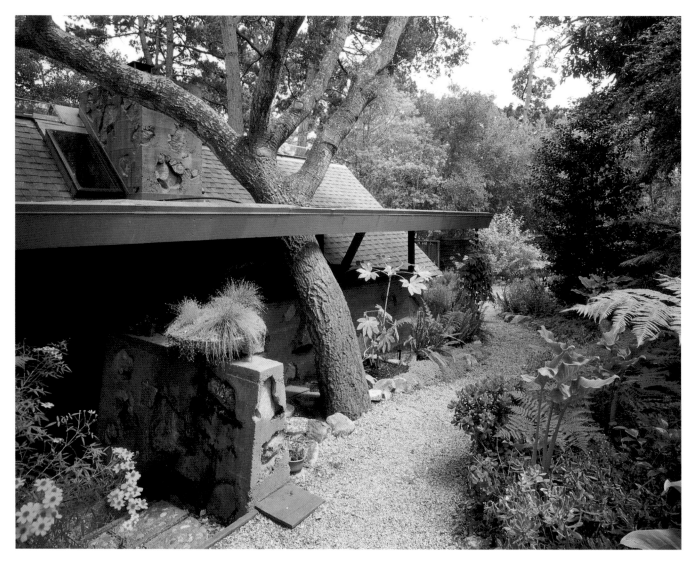

Stairs descend to the entry and a path leads to artist's studio on the back of the property.

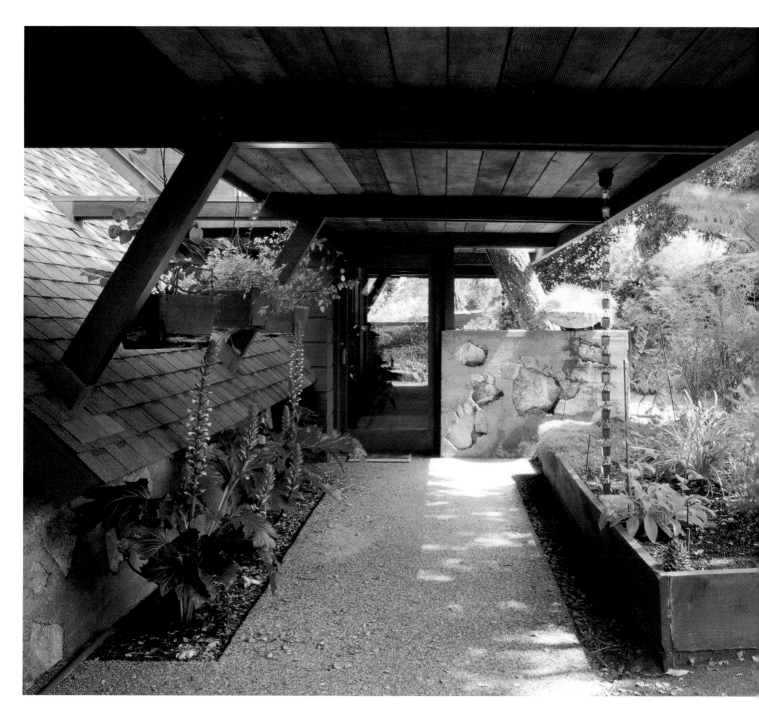

The entry is under a flat roof. Large leafed acanthus grow along a low sloping roof line.

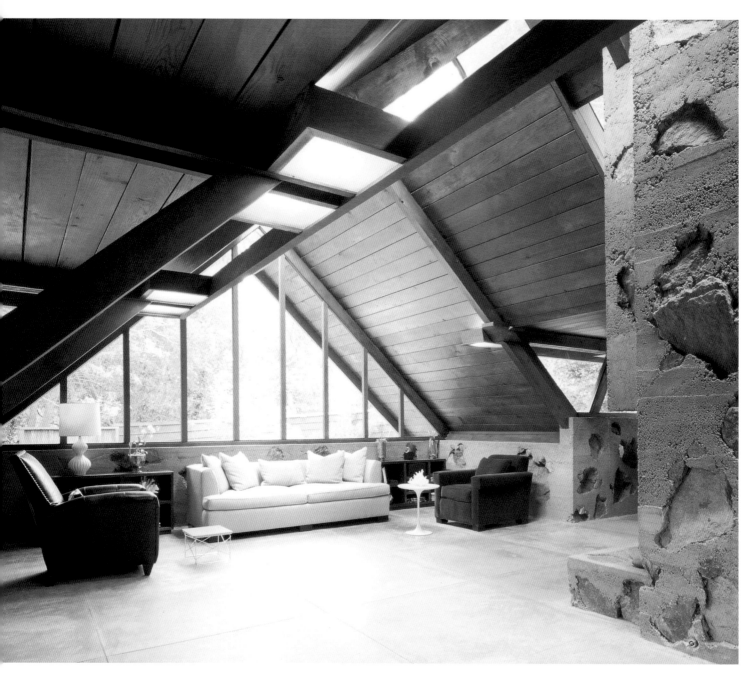

The beams of the A-frame rest in the "desert masonry" concrete walls.

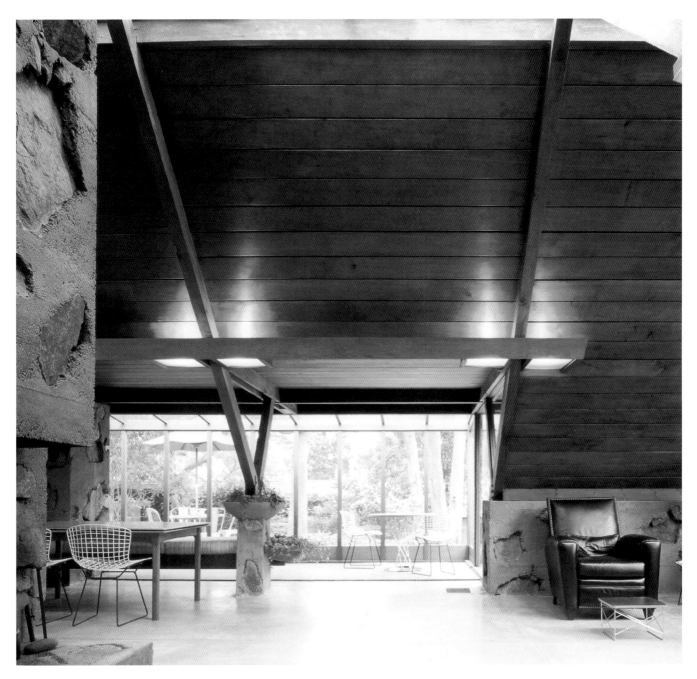

A buff-colored concrete slab, grooved floor runs throughout the cottage.

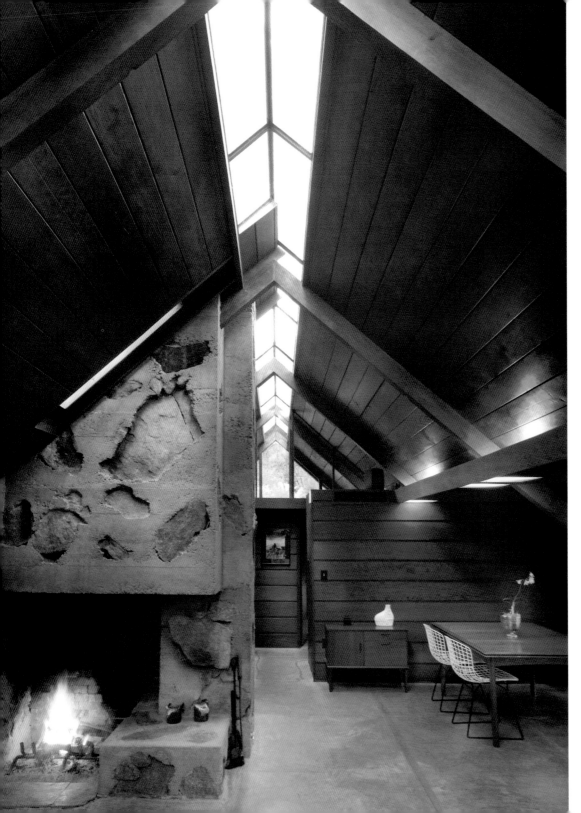

A mitered glass skylight runs the length of the roof ridgeline. Skylights frame the chimney of the living room fireplace.

The faithful Barney reads his favorite book about Carmel cottages.

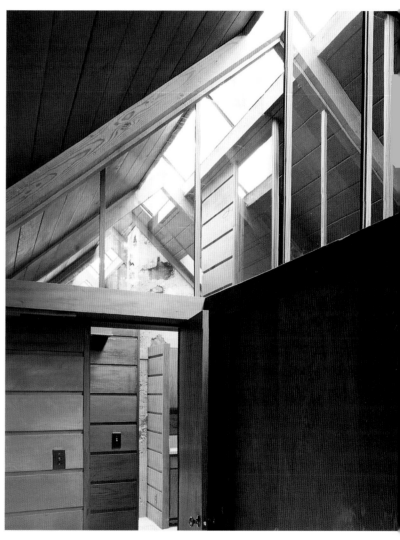

Natural light floods the cottage.

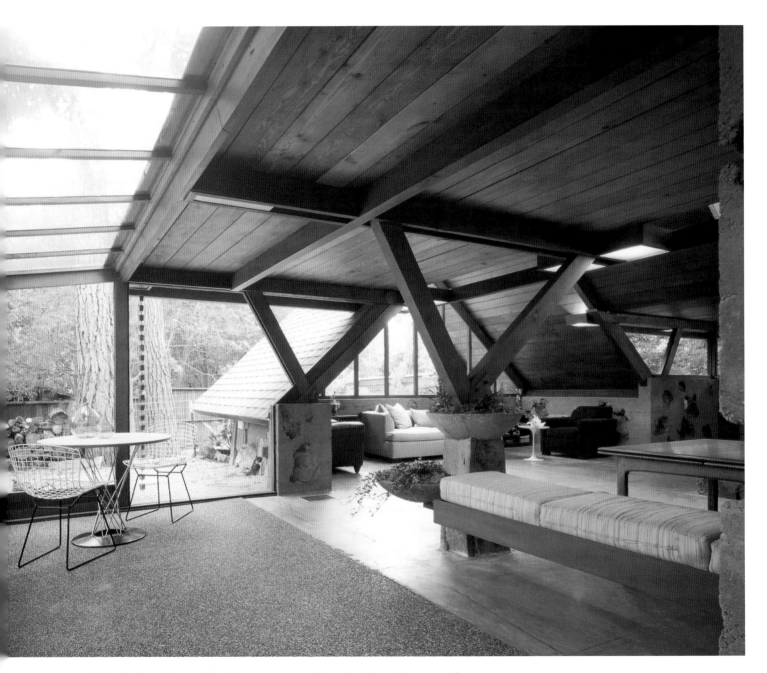

The floor plan is so well executed, interior space appears much larger than the overall 1203 square feet.

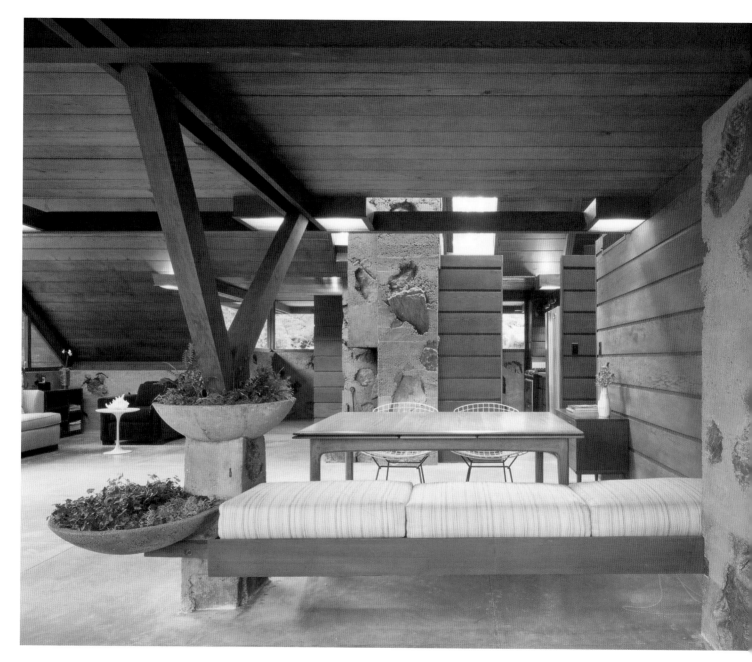

Built-in furnishings and planters are reminiscent of designs by Mills' mentor, Frank Lloyd Wright.

Bainbridge Island Cottage

ARCHITECT: Stuart Silk, AIA, Stuart Silk Architects

PHOTOGRAPHERS: Laurie Black; Stuart Silk

THE BEST PART OF HAVING a cottage on Bainbridge Island is that within thirty-five minutes on a slow-moving ferry, downtown Seattle is a very distant psychological state. Moving from New York to be the team doctor for a professional Northwest sports team, this husband and his family wanted to remind themselves of Hampton summers by designing a cottage in the shingle style. This is a reprieve from the energetic growth of the city and a perfect quick getaway for a busy family.

A guest cottage deep in the gardens of the property.

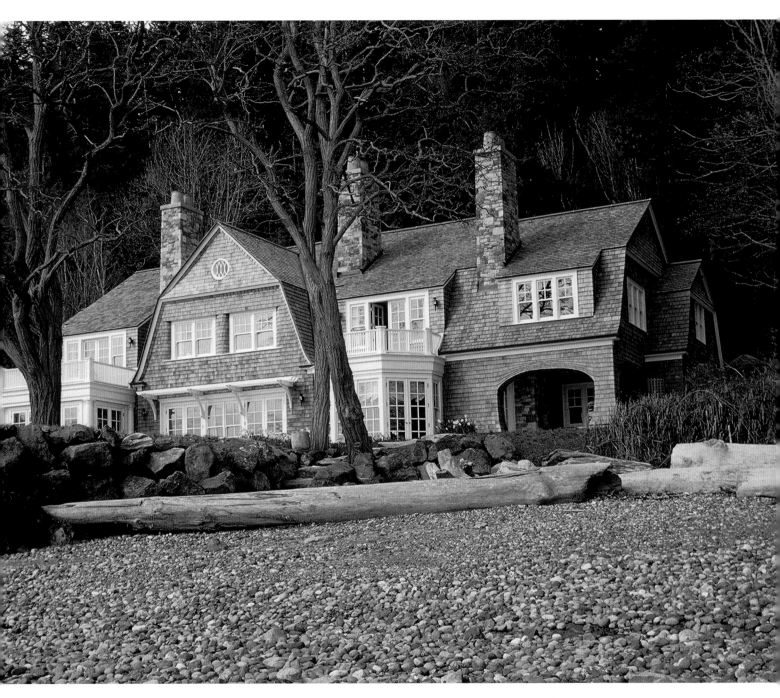

The shingled cottage looks over stony beachfront.

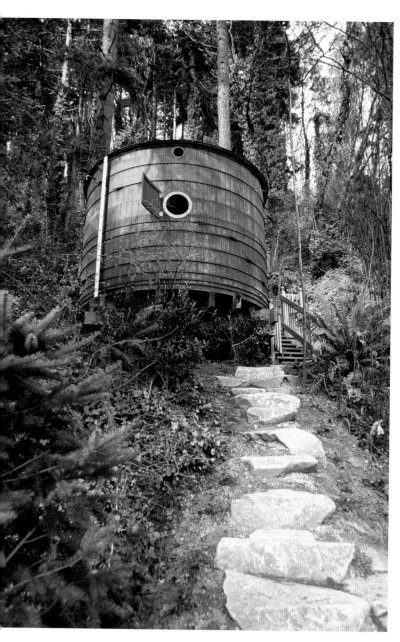

A children's playhouse in the landscape made from an old water tower

On a picturesque and private lane, this cottage sits far back on the site and faces south, taking full advantage of the views of Puget Sound and Mt. Rainier, eighty miles away. The siting on the property is semi-isolated, with a guesthouse further back near the trees. Beyond the guest house is an old water tower that has been painted and renovated into a playhouse and bunkhouse for the children.

The main entry is along a stone path leading to a Dutch door that is offset by large eighteen-paned windows. Three small overhead sets of glass allow as much natural light as possible into the classically proportioned two-story entry. The gambrel roof lines accentuate classical balconies above extensive sets of French doors surrounding the exterior of the house. The design focus is the gathering space around the kitchen. Living and dining areas are casual; furnishings are intended to look as though they've been in the family attic and recently rediscovered. The outdoor patios have multiple seating areas and one special dining area with a large stone fireplace. Outdoor dining is, however, not limited to one spot; there are terraces, open porches, and covered patios. The fading patina of the cedar shingles shimmers slightly as the shingles themselves curve around window and door frames. Darkening every year, the exterior is accentuated by the ever-changing colors of the Northwest sky. The oriel windows high above the terraces and the colorful stonework of the fireplaces, terrace wall, and the chimneys capture the light or hide from it, as the cottage dissolves in and out of view.

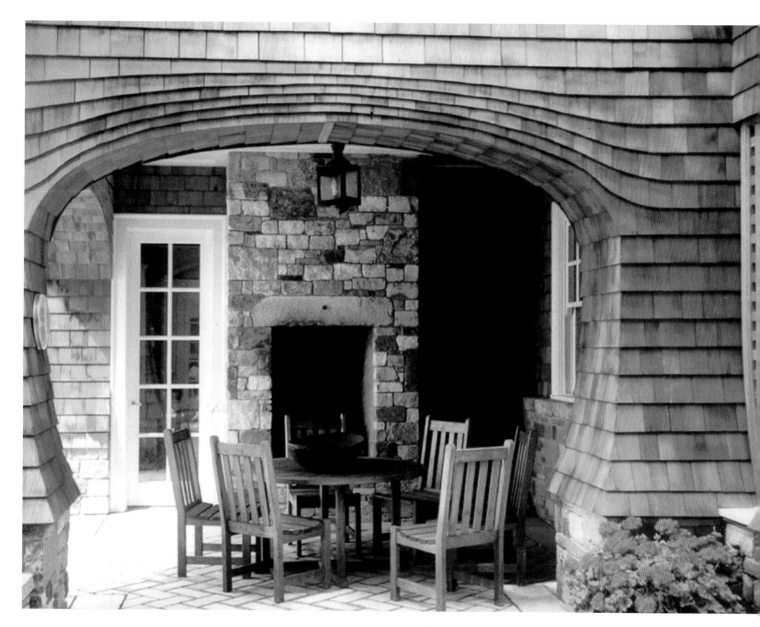

A covered outdoor dining alcove of shingles and stone offers views of the Sound.

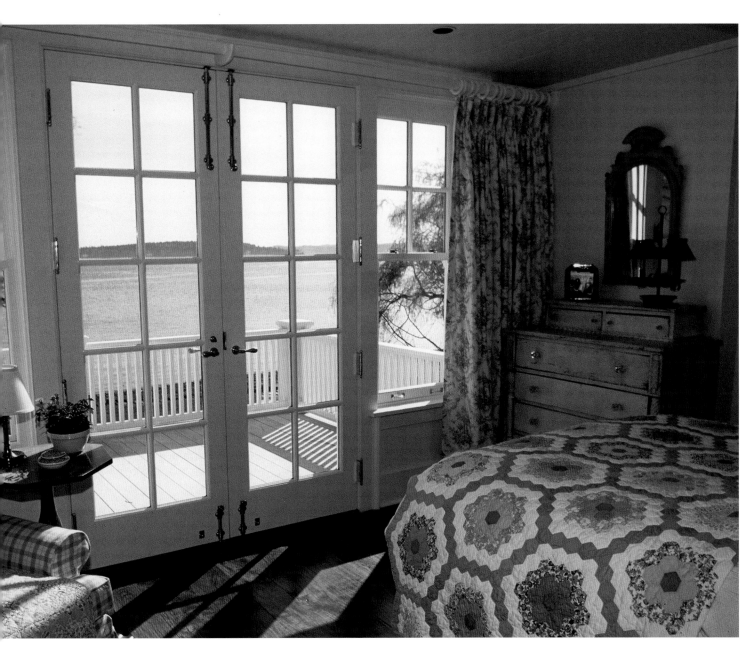

The design was intended to recall Hamptons cottages., with views from every window.

The sunroom walls are clad in shingles to appear as an "add-on" room, in the vein of vernacular architecture. ▶

156

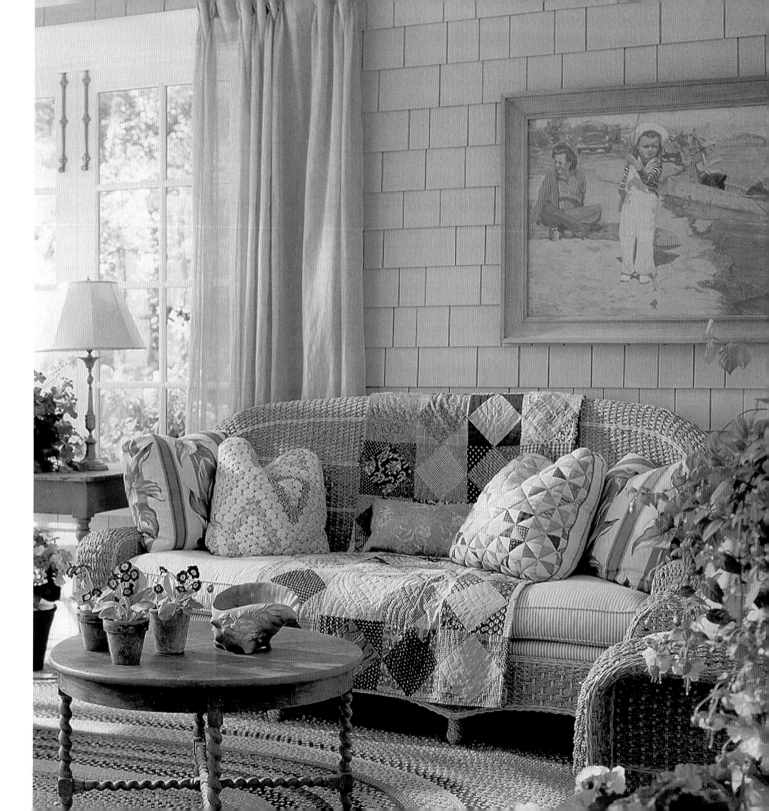

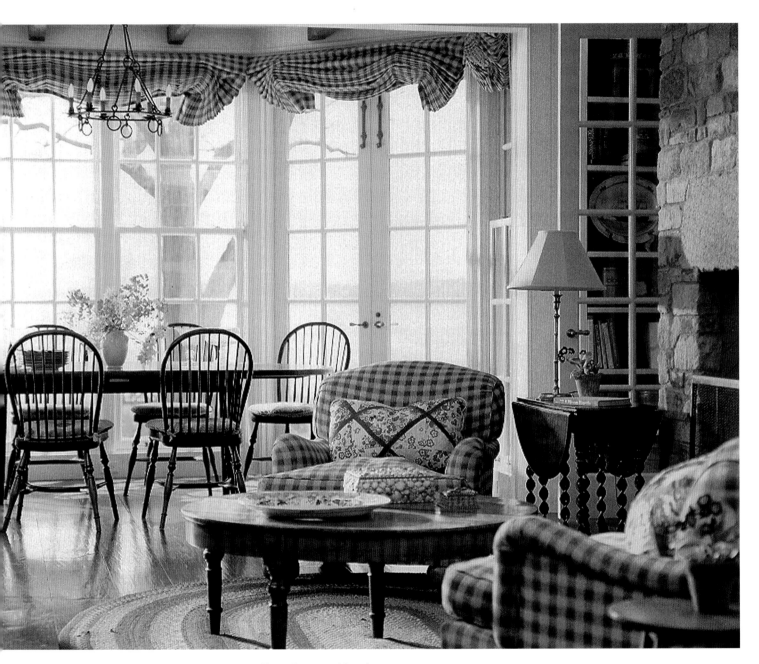

Relaxed furnishings fill the cottage with an air of having been rescued from the attic.

French doors let in the sunlight. The fragrance of the Puget Sound is unmatched: a mix of fresh- and salt-water.

gin and tonic on the porch

Beach and cabana days on the Atlantic

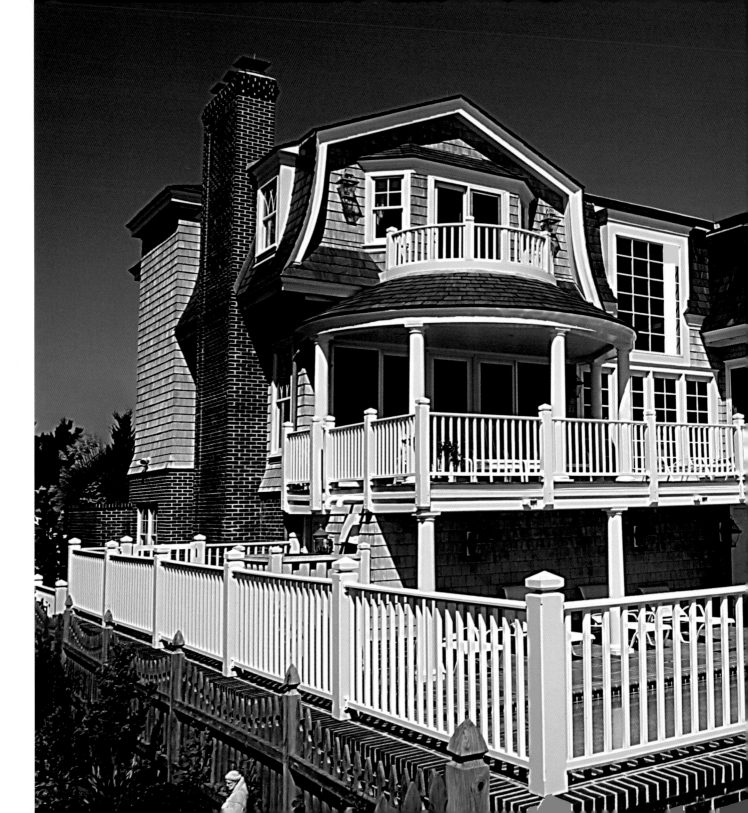

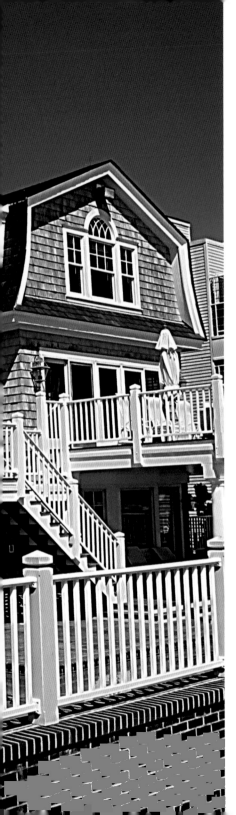

Elegance and a post-Victorian design result in exterior efficiencies housing light-filled interiors.

Mid-Atlantic Cottage

ARCHITECT: Robert A. Johnson, AIA, The Johnson Group, Margate, New Jersey

PHOTOGRAPHER: John DiMaio

THIS POST-VICTORIAN COTTAGE is an evolution of its area's indigenous architectural styles. It is set in a coastal community that has a long tradition of Victorian and post-Victorian houses, many of which have been lost to various disasters, including marauding development and ocean storms. Architect Robert Johnson was asked to design this cottage as a replacement for a contemporary one he had designed for the same owners on the same site that had been lost.

Earlier coast cottages were designed in a "Jersey Seashore" vernacular with gambrel roofs and sweeping porches. The clients wished to recapture the sensibility and ease of an era. They wanted to avoid the small rooms associated with Victorian interiors and asked the architect to completely open up the interior. The largest open space is where the first floor is opened through the second floor level. Facing the ocean, the house is flooded with light and spaciousness. The high ceilings mixed with floors that vary in elevation on landings and stair levels emphasize the flow of light, space, and ocean views at every level.

A brick and landscaped entrance opens into the main living area of the cottage, which further heightens the sense of openness, while insuring privacy from nearby dwellings. The formality of the furnishings creates a luxurious contrast with the open floor plan, but is consistent with the exterior

formality and detailing. At the ground level the architect designated space for showers and changing rooms for the enjoyment of beach, pool, and garden activities.

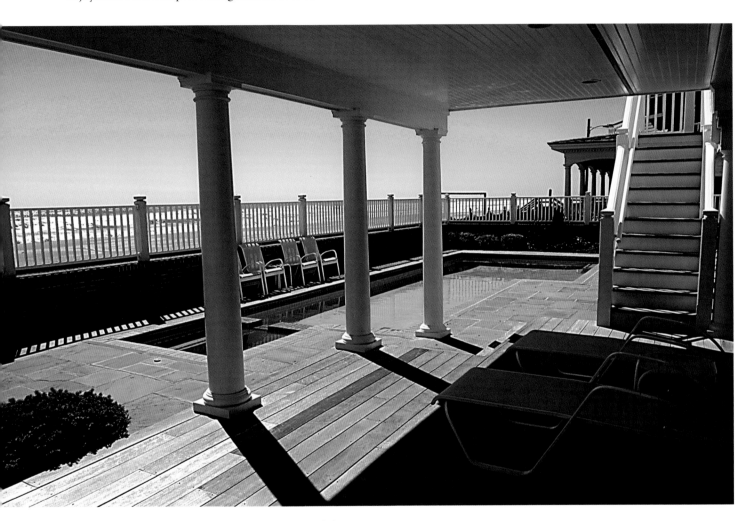

The pool and beach activities take place on and near the lower level of the cottage, where shower and changing facilities are nearby.

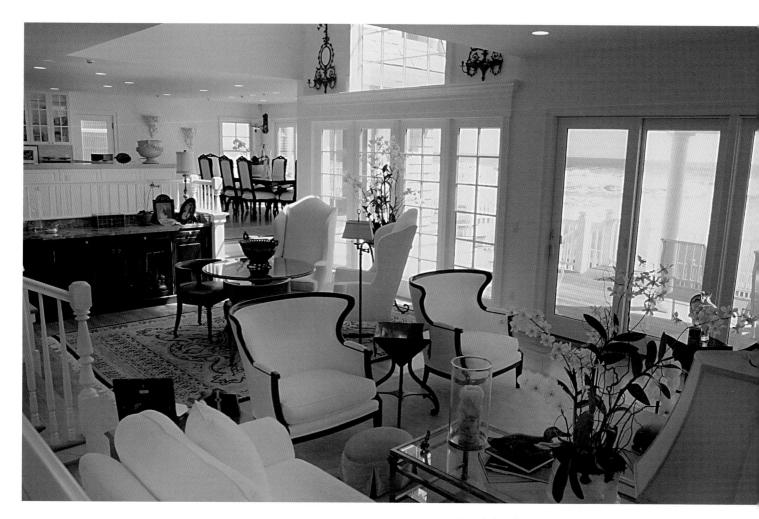

A stairway descends from the entry to reach the main level of the cottage providing a living room with a two story view of the ocean.

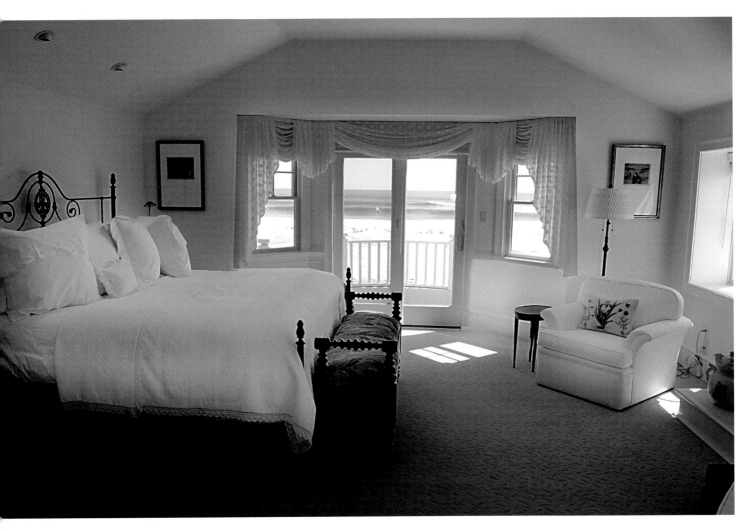

Sleeping quarters on the third floor face the rising sun,
the ocean and breezes with small balconies.

A hand-carved image of Atlantic salmon is on the center door panel.

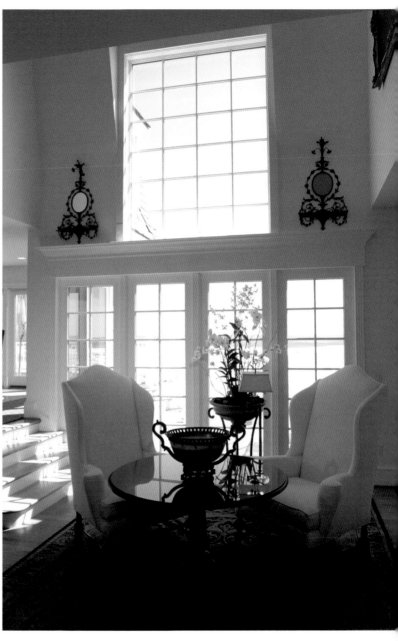

French doors and small-paned windows fill the two story living room with light.

Mitchell Cottage
on Spring Island

OWNERS: Ed and Ginger Mitchell

DESIGN TEAM: Jim Strickland, Terry Pylant, and Ryan Yurcaba

PHOTOGRAPHER: Richard Leo Johnson

LOCATED ON SPRING ISLAND, South Carolina, this design is a casual coastal cottage layout. The interiors are warmed by the use of rich woods and timber frame construction. The cedar shingle facade is masked in cool summer shadow by large eight-foot overhangs. Large scissor brackets support the weight of the overhangs and, along with big operable Bermuda shutters, lend a whimsical feel to the exterior. Round pilings raise the cottage above a flood plain and also allow the coastal breezes to cool the ground and the house from below. The modest exterior coupled with a broad front stair is a welcoming invitation to visitors and guests.

The heart of the cottage is the gathering room. The use of many different species of wood, from the pine and heart pine floors to the cypress on the walls and ceilings, provides an additional sensory element to the design, and the aroma of the natural materials is a joyful surprise to the senses. Designed to focus the view across the wetlands and marshes toward the Callawassie Creek, four sets of French doors open onto the large, 1,214-square-foot screened porch, leaving only timber posts to separate the indoor and the outdoor living areas. The porch is punctuated at each end by smaller sleeping porches, one of which is complete with a swinging bed. Sliding shutters in pocket walls are used throughout the open floor plan to allow for privacy when needed.

The large gathering room is flanked by two alcoves. The master suite is on one side of the cottage, and two guest rooms are on the opposite side of the large central room. The master suite has wonderful marsh and wetland views. The guest rooms provide casual and comfortable sleeping quarters. The coastal views can be enjoyed from the galley kitchen. Nestled in the lush foliage of an unspoiled coastal island, this cottage is complete with playful elements that heighten its casual appeal.

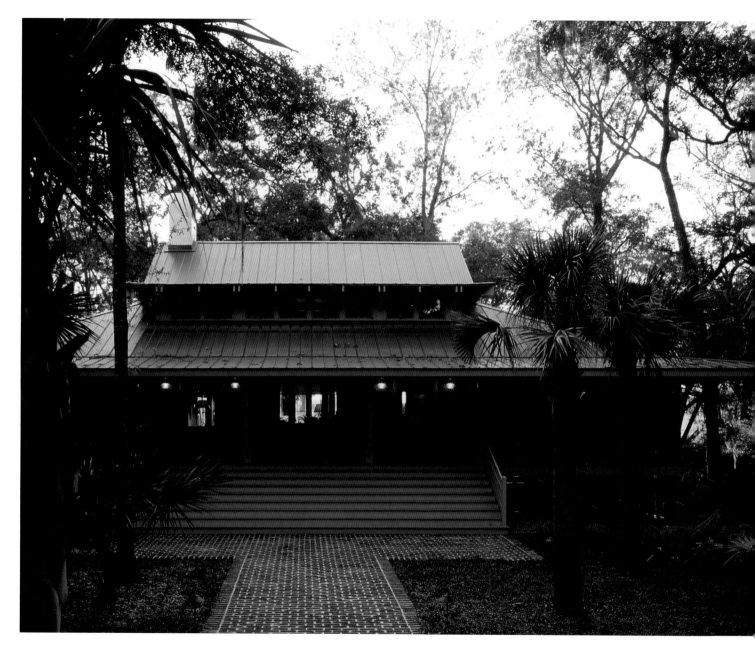

A broad front stair beckons guests to this cottage, inspired by traditional Carolina coastal architecture.

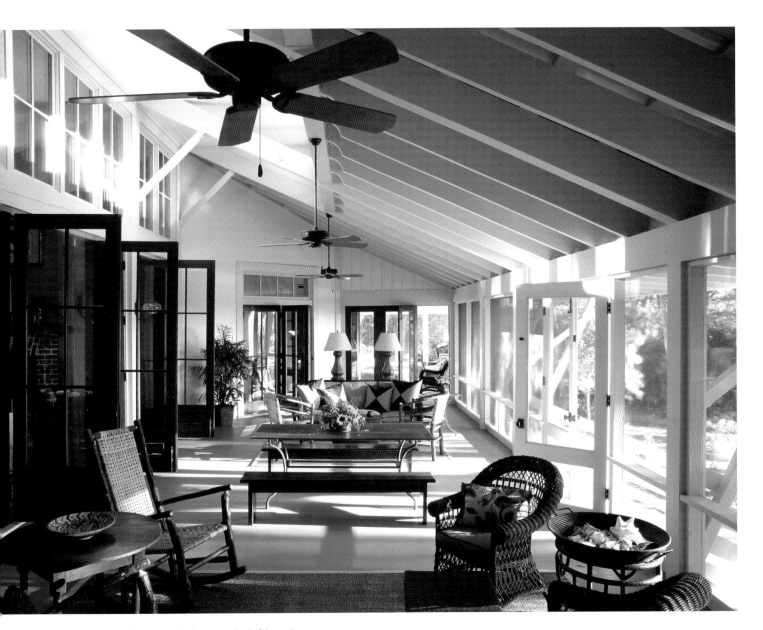

This large porch accounts for almost one-third of the total square footage of the cottage. Screened porches take full advantage of the untouched coastal setting.

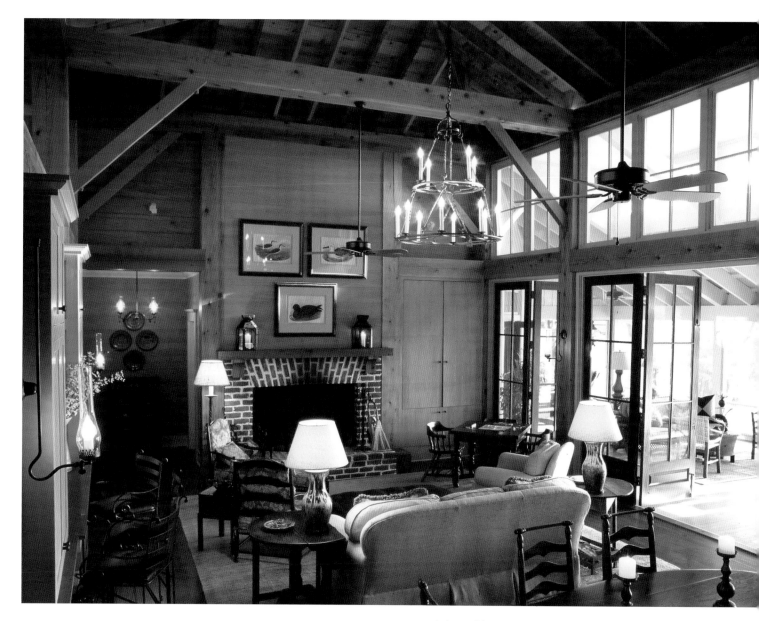

The heart of the cottage is the gathering room. Interior clerestory windows show off the different species of wood used in the interiors.

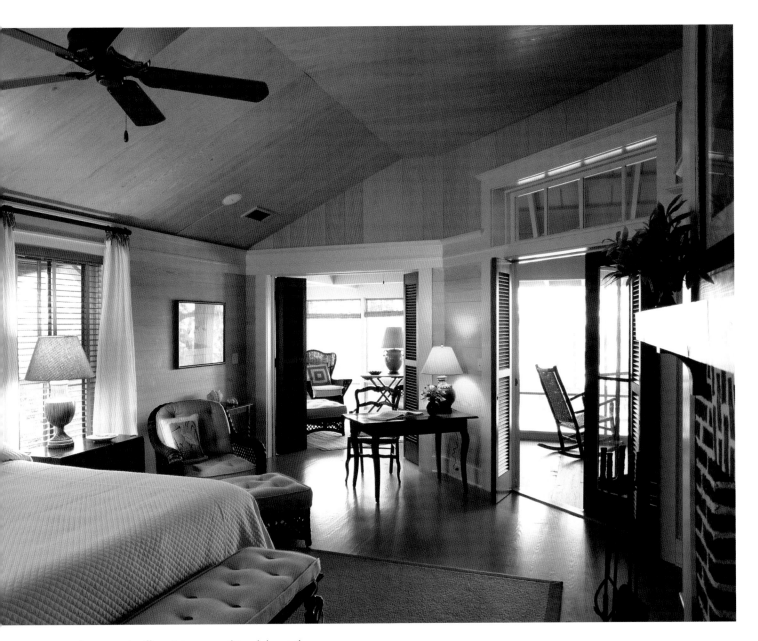

The master suite offers a sitting room and French doors to the screened porch. Cool evenings can be warmed by the brick fireplace.

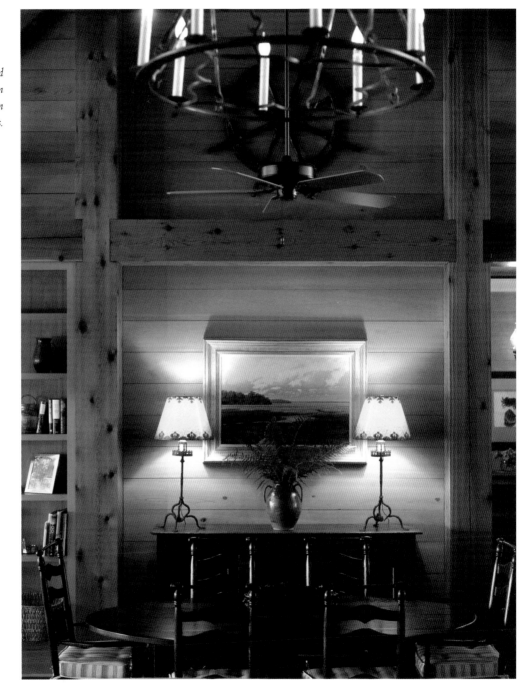

Antique lighting, heavy wood posts and beams with horizontal wood planks on the walls, and shelving provide a warm glow in the evenings.

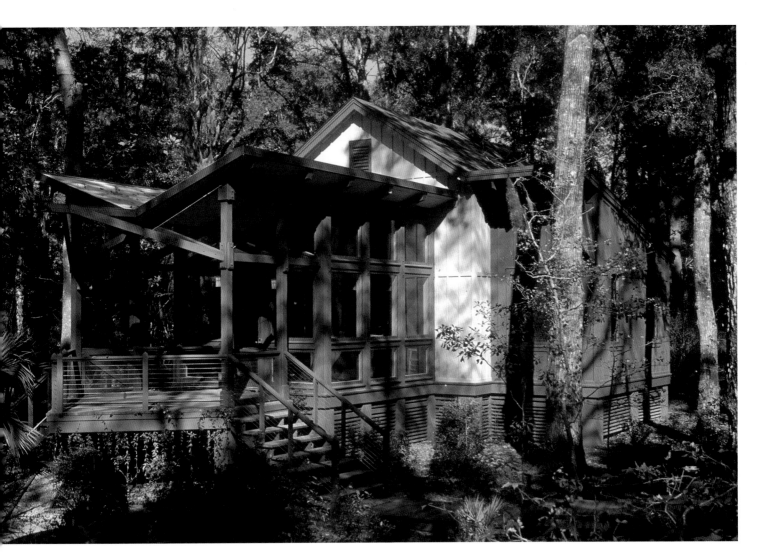

Spring Island guest cottage is a refuge until the owner's main cottage is built.

Colt's Guest Cottage

OWNERS: Mike and Nancy Colt

ARCHITECT: R. Christian Schmitt, FAIA,
Steven Wells, AIA, Project Architect
Schmitt Sampson Walker, Inc.,
Charleston, South Carolina

PHOTOGRAPHER: Dickson Dunlap

THE COLT GUEST COTTAGE is located on Spring Island, South Carolina, a 3,000-acre coastal barrier island located between the historic city of Beaufort and the resort community of Hilton Head. The Colt property is adjacent to an abandoned rice pond that is a haven for both fish and water fowl, and is a home to a family of alligators. The island is heavily wooded with a wide variety of trees including live oak, pine, palmetto, and water oak. Land conservation and minimal impact are kept in the forefront when construction takes place on the island.

The concept for the Colt project was to build a series of smaller buildings that would easily blend into the environment. The first phase of the project includes the guesthouse, a garage, and a shop. The guesthouse is the first building of a small compound that will include a main house and a studio. The guesthouse allows the Colts to enjoy their property and their weekends until the main house is constructed. The buildings are simple in form, with detailing that gives a sampling of what is to come with the main house.

The portion of the guesthouse containing the bedrooms, bathrooms, and kitchen is a very simple form. The sitting room is more expressive, as it establishes the strongest relationship between the interior space and the immediacy of the landscape just a few steps outside. The emphasis on being with nature was the primary consideration for the design of the sitting room. By a reversal of the form of the roof structure, the views are opened to the full height of the tree canopy. The exposed structure of the sitting room extends through the glass walls and out through the exterior porch deck to further merge architecture and landscape.

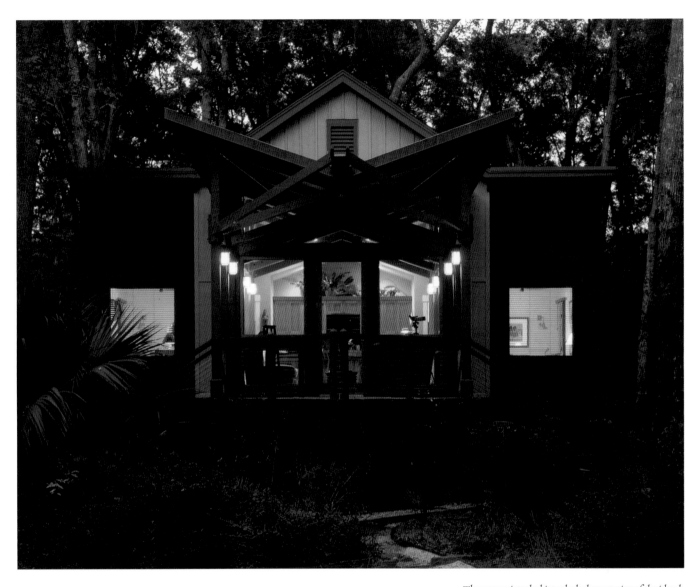

The cottage is tucked into the lush vegetation of the island.

◀ The small studio with a tool shop is a few steps from the cottage.

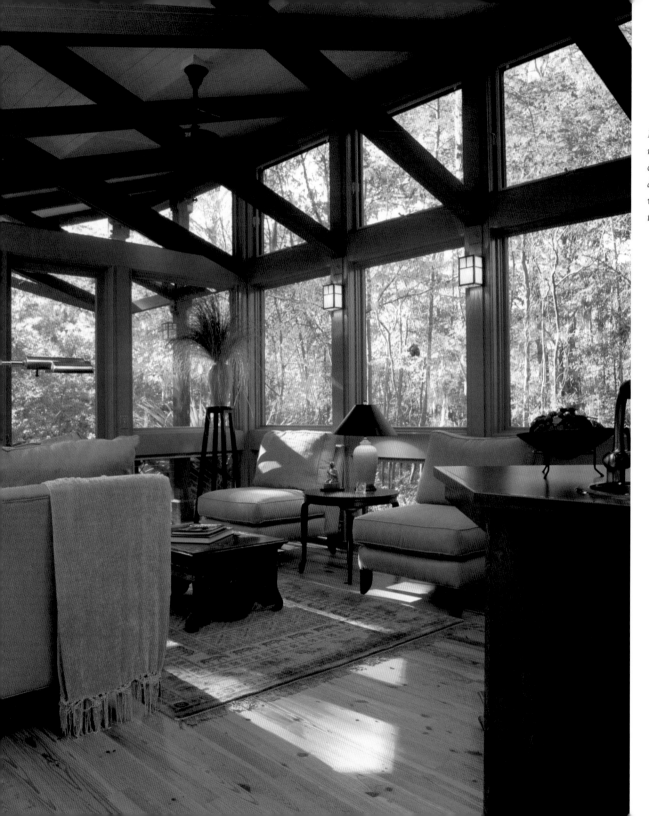

Interior architecture reveals the cross beams of the ceiling and roof design. The wall of windows emphasizes the nearness of nature.

The living room ends with a small bistro table and small kitchen.

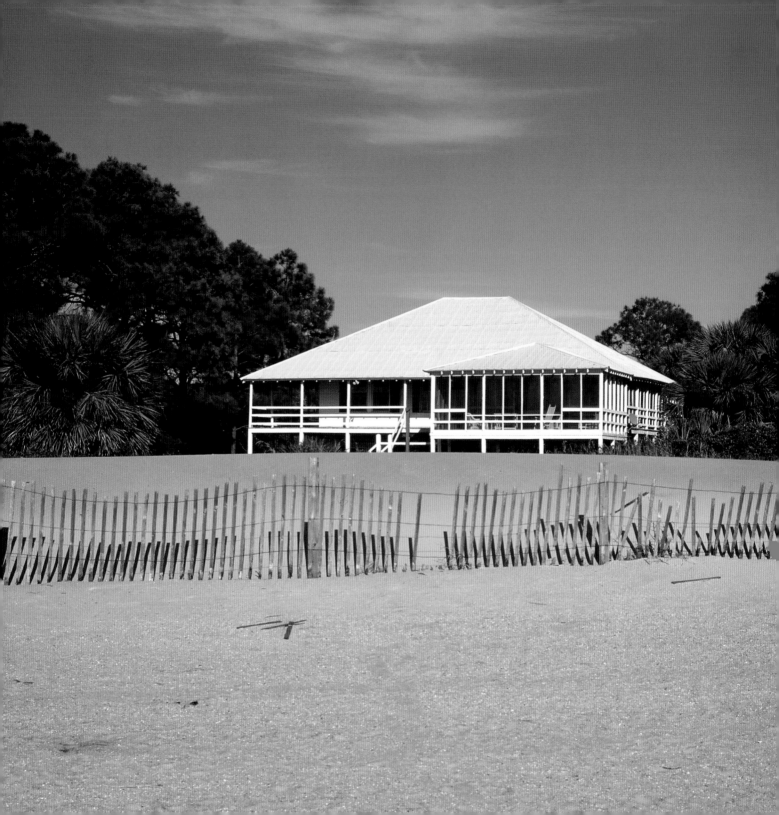

Lynah Cottage on Tybee Island

OWNER: Mrs. Wallace Lynah

BUILDER: Vernacular

PHOTOGRAPHER: Richard Leo Johnson

NEAR THE TURN of the twentieth century, Tybee was settled by a few cottages, most of which faced the ocean and the inlet. The group of cottages facing the inlet was called Colony Row. All are believed to have been built by the same builder, possibly A. P. Soloman. The cottages all shared the same square shape and the same roof form, and each had a hired hand's house built on the back of the cottage. Mrs. Lynah's cottage is a variation of the original Colony Row style. The first owner, Captain George P. Walker, a founder of Strachan Shipping, wanted to build a sitting room over the hired hand's quarters to catch the north, south, and easterly breezes that would blow through with cooler evening temperatures. When it was finished, it was a grand room; however, with no electricity on the island, Captain Walker could not light the passageway from the cottage porch to the new room itself. "Roll it away," the captain told the builder. The builder was then asked to build a new cottage exactly like the original one, but in which the new room would be flush with the walls. The new, larger cottage has had a notable line of descent culminating in its purchase by Wallace and Helen Lynah in the autumn of 1971.

A lover of travel and a lifelong hiker, Mrs. Lynah has hiked among the stone cottages, bridges, and chateaus in the lush landscape of the Dordogne region of France; the Inca Trail at a 14,000-foot elevation in Peru; and in Nepal at the 15,000-foot level. She is looking forward to hiking northwestern Washington's Olympic Mountain Range. The Tybee cottage is her summer home. It is where she and her late husband brought their three children to grow up on the water; to boat, swim, and fish.

Mrs. Lynah's cottage has an abundance of unspoiled, original woodwork in the interiors. The floors, walls, stairs, louvers, and even the ceilings radiate a welcoming glow. The entire interior of the cottage is outfitted with choice heart pine. When the cottage was built in 1903, there were no roads to Tybee, and all the building materials were brought to the island by barge. Mrs. Lynah recently had the wood floors coated with easy-maintenance polyurethane to protect them from beach sand. After thirty-three years of ownership and a dedication to the continuous duty of repainting the exterior and replacing of screens, this 101-year-old cottage glistens with the authentic flavor of the island's own vernacular style.

◀ *Tybee Island vernacular cottage, built in 1903*

Screened porches and open corridors catch the breezes from the water.

Long wooden paths cover vegetation for a smooth walk to the sandy beach. ▶

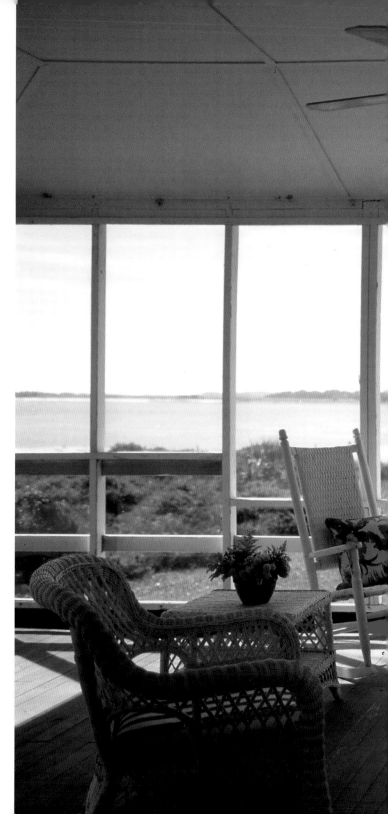

Large screened porches are the living rooms of the Tybee cottages.

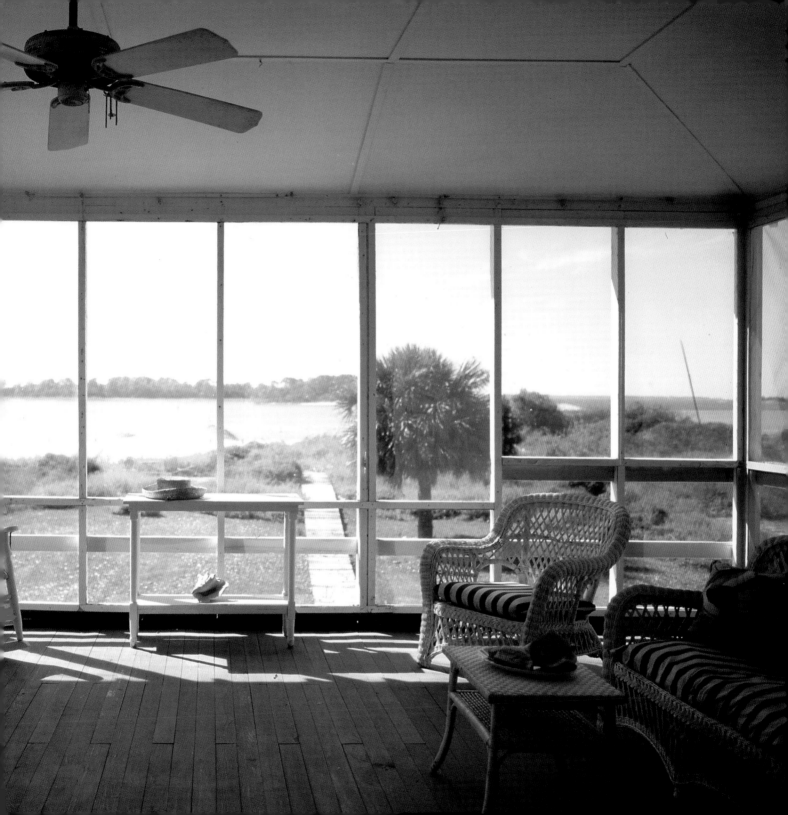

Stairs, risers, balusters,
banisters, and railings are all
made of the 1903 heart pine.

◄ 1903 barged-in choice heart
pine finished every surface of
the cottage interior; second
story louvers, ceilings, walls,
doors, and floors glow with
the warmth of original wood.

The cottage living room is large and furnished in a simple and graceful manner.

Toys and games from the game bench

Welcoming room with a screen door

Randolph Cottage on Tybee

OWNERS: Mrs. William H. Randolph, III

BUILDER: A. P. Soloman

PHOTOGRAPHER: Richard Leo Johnson

TYBEE IS A SMALL ISLAND eighteen miles directly east of Savannah, Georgia, located at the mouth of the Savannah River. It is a narrow island, with two miles of beach and sand dunes on the ocean side, and natural wetland marshes and quiet beaches on the other side, called the Back River. The Southern end curves around a point called the Inlet. This is where the mouth of the Savannah River flows into the sea. The name "Tybee" is thought to be a derivative of the southeastern Euchee Indian word for "salt," one of the many plentiful resources found on the island. As a site for valuable natural resources, the island was held under the flags of many countries in the early years of exploration. Spain flew its flag over Tybee in 1520 and declared it a piece of "La Florida," a tidy parcel of oceanfront that ranged from Nova Scotia to the Bahamas. The French, too, of course, loved Tybee. They sought an aromatic native plant called sassafras, a member of the laurel and sweet bay family. Sassafras, with its greenish-yellow flowers, leaves, and bark, has a spicy aroma. The bark and roots were dried and used for medicinal purposes—it was considered a miracle cure in Europe—and it was used as a tea. Bark oil was extracted for use in perfumes. Tybee had something for everyone, as early as the sixteenth century.

Mrs. Randolph's cottage was built in 1909 by local builder A. P. Soloman, some of whose family members still live in Tybee. The Randolphs learned that the cottage which they purchased in 1967 was one of many designed and built in the same vernacular style. The most common features were the square shape and the use of large porches, both enclosed as screened rooms and as large sitting porches on the outside. The outdoor porch faces the water, sheltering five or six woven birch rockers from the heat and sand blowing from the dunes. One porch was screened on three sides and is large enough for afternoon tea parties of fifty to seventy-five guests. Mrs. Randolph and her family spent every summer and Christmas at the Tybee cottage, where their favorite recreations included crabbing, shrimping, fishing, and swimming. After a good swim, a refreshing shower could be had under the cottage in the "bathhouse" below—a perfectly cool place for washing off the beach sand before going upstairs.

The interior rooms of the cottage are romantic, with

The morning sun rises on Mrs. Randolph's cottage, where an invitation includes, "bring your dogs and cats…."

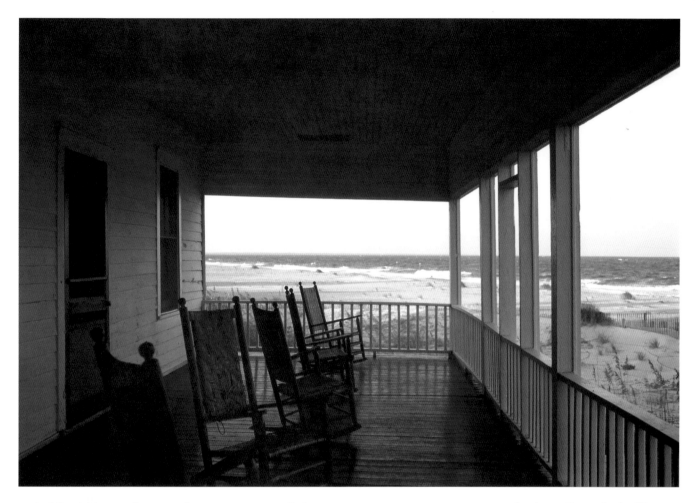

Dunes and sand grass roll out to the edge of the water.

period furnishings and a meticulous arrangement of white walls and fabrics, heart pine floors, and dark wood trim. The more formal living and dining rooms feature classic furniture in white upholstery, slipcovers, and delicate curtains. In contrast are the many hand-carved dark wood mirrors and frames. Bentwood chairs and the dining table and chairs glow softly before restful watercolors of marina fauna. The areas for more casual activities are wispy with wicker, painted tables, and shuttered windows. The kitchen is a breath of cool calm. Oh Tybee, oh Tybee.

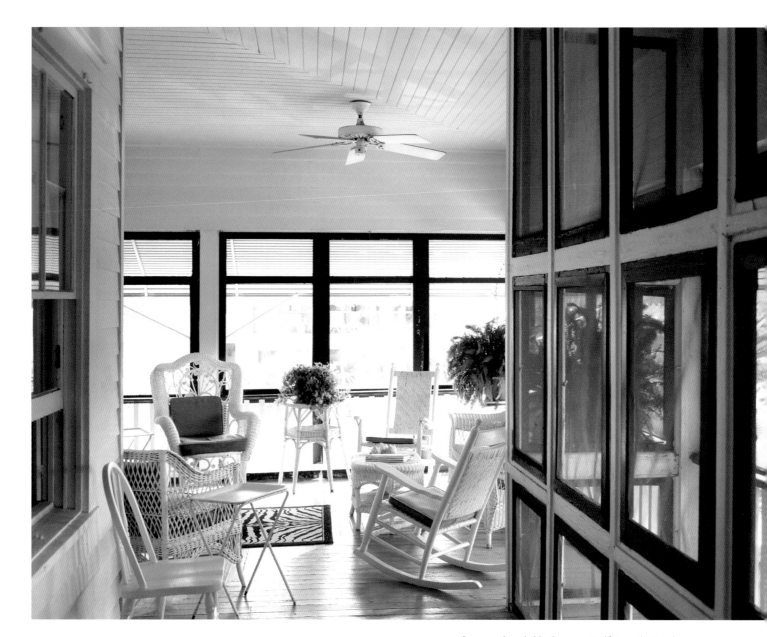

The screened porch, like the cottage itself, is a gathering place for generations of Randolphs.

Mrs. Randolph keeps a quiet, stately cottage where the floors "never need sweeping."

An early en suite washing bowl sits near a mirror, which reflects the encroachment of time.

Southern mirrors hold the echoes of the Randolph family gatherings at Tybee cottage.

194

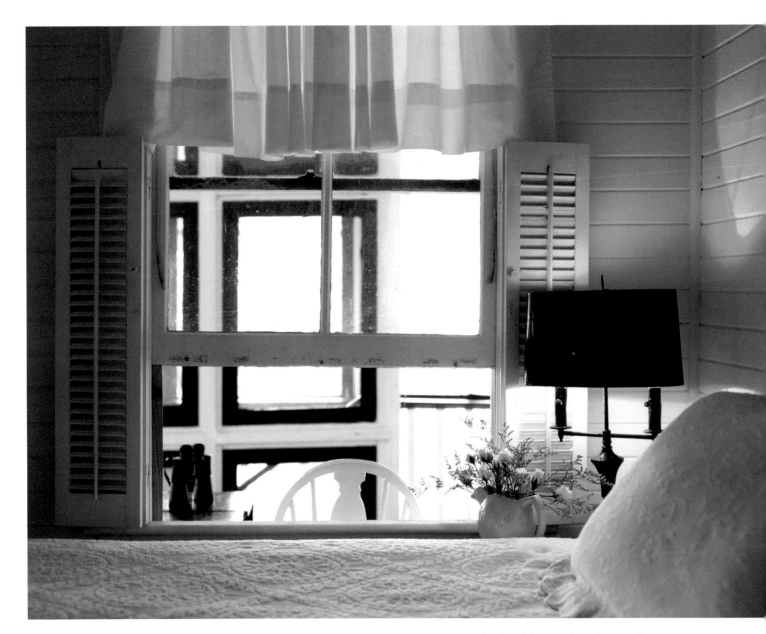

Chenille and shutters and a small bouquet for a quiet nap

Paskin Beach House

OWNERS: David and Linda Paskin

ARCHITECT: Robert A. Johnson, The Johnson Group, Margate, New Jersey

PHOTOGRAPHER: John DiMaio

At one time, a boardwalk connected several down-beach communities to Ventnor, New Jersey. The boardwalk was a favorite place to spend a morning or an afternoon walking or cycling or just being on the beach having fun with friends. Over the years, many parts of the old structure were destroyed by storms, rebuilt, and destroyed again. Only Ventnor has rediscovered the social and civic importance of the structure. There the old boardwalk has been restored or replaced where necessary and is presently recognized and maintained as vital to the recreational community.

David Paskin and his wife, Linda, are avid cyclists who enjoy nothing more than getting out for an early morning ride on the boardwalk at any time of year. The boardwalk was one of the main attractions for them: Dr. Paskin had owned the house directly next door to their new residence for many years. The compact new site (50 by 62.5 feet) called for a vertical design with a wraparound porch to serve the clients' needs, as well as fit the scale of the neighborhood. The Paskins share an enthusiasm for cooking and conversation, so the house is designed for frequent entertaining, with a large open kitchen and dining area. The generous covered porch serves as additional space for entertaining and is often used for outdoor dinner parties. The two-story living room allows ocean views from the second floor corridor and floods the entire first floor with sunlight. Arts and craft works are found throughout the cottage, and a portion of the third floor houses the owner's extensive collection of model trains and a completely landscaped ten-by-fourteen-foot working platform. The collection was begun thirty years ago, and all are exact replicas of past and current narrow-gauge railroads in Europe. The trains have sealed motors and can be run outside. Now there is a terrific new use for the boardwalk!

The cottage benefits from a compact corner site with a large, broad wraparound porch. ▶

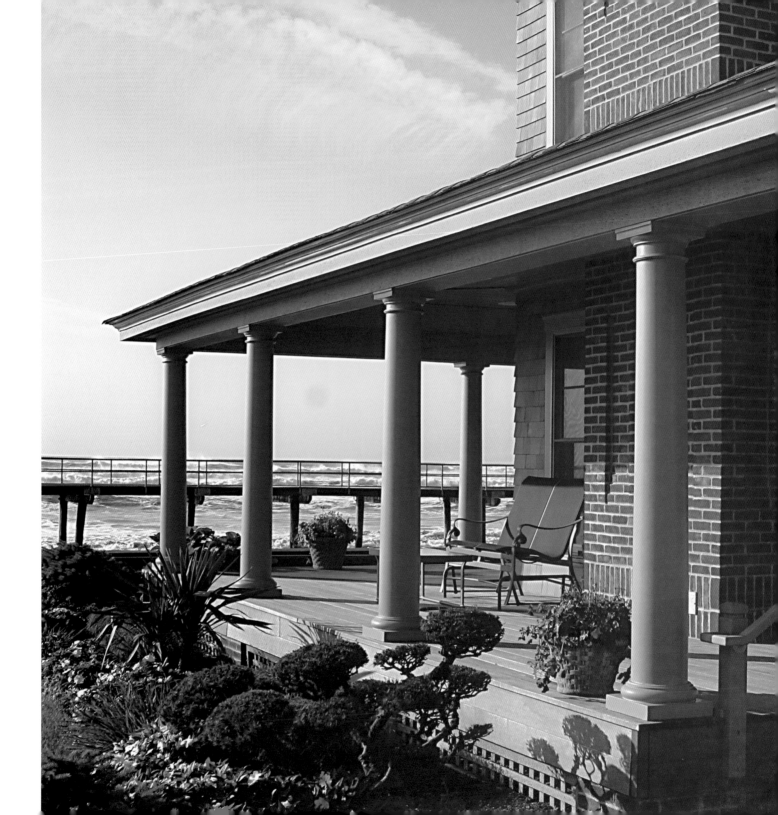

The boardwalk is a favorite place for early morning bike trips.

Beach, ocean, bird, and people watching are day-long pleasures.

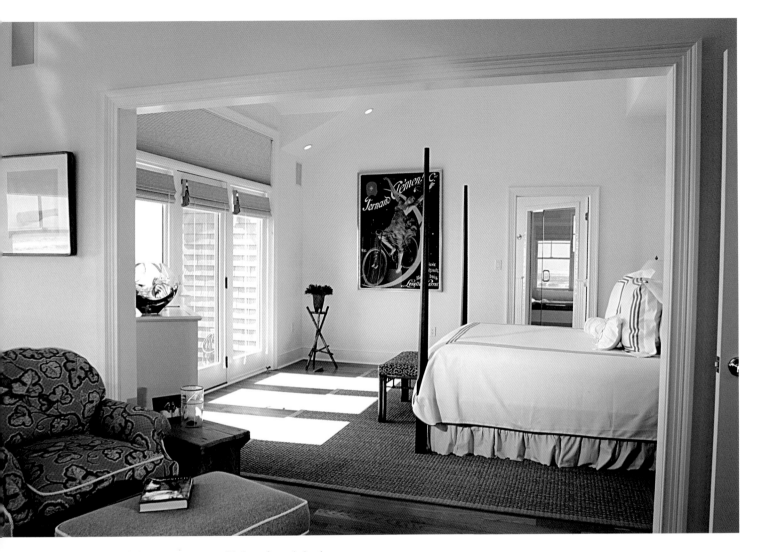

The upstairs bedroom opens onto a small balcony facing the beach.

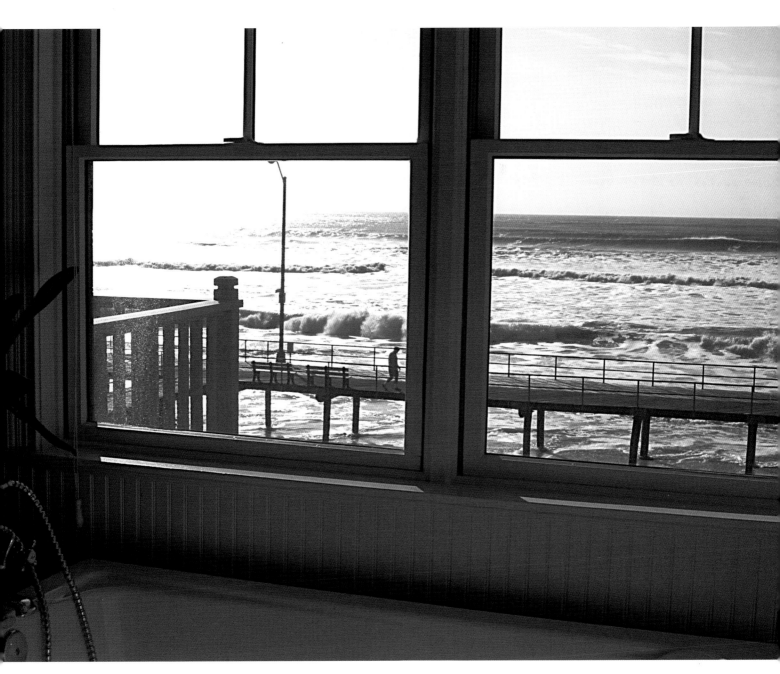

A lovely lounging tub in the upstairs suite where the sounds of the waves can be heard

Collection of model trains built on a
ten-by-fourteen-foot working platform

Avid collectors, the Paskin's cottage
features trains, paintings, and the glass
of Morris, Pavlik, and Chihuly.
Still Life of Bottles *is by*
Bernie Donofrio.

The cottage filled with art: The gorilla painting is oil on canvas by Tom Palamore.

The morning sun fills the palm trees and the great lawn with glimmers and shadows.

Henderson's Cottage

OWNERS: Dick and Delaine Henderson

ARCHITECT: Vernacular

PHOTOGRAPHER: Emily Minton-Redfield

THE HEARTS AND SOULS of Delaine and Dick Henderson surrendered to the call of their dreamy and exotic vacation haven when they decided to live the Gulf life full-time. West of the mouth of the Apalachicola River in the Gulf of Mexico are Indian Pass and a place once called the "pearl of the South, Old St. Joe," in northwestern Florida. Years ago the Hendersons discovered the area of early-nineteenth-century hunting and fishing camps there. The camp buildings were large and sturdy, often with massive screened porches and plenty of room for gamesome and resourceful sportsmen and women. Hunting near Apalachicola and Indian Pass was an American version of safari—the quarry was wild boar and the hunt was the beginning of an ongoing tradition of pig roasts on the beach. Fishing was the classic vision of catching the large, silvery game fish with the bluish back. Men went out together in boats for the adventure and the fight; a tarpon was often three to five feet long. A noteworthy outing would result in four or five tarpon, which led to fabulous evenings of roasted fish and good cheer.

Dick and Delaine were lucky enough to capture one of the hunting camp retreats. The cottage sits deep back on a great, green lawn speckled with palm trees. A large screened porch faces the lawn. The views on the other side of the cottage are open, spacious, and vibrant. The many French doors and vertical paned windows are enhanced by breezes from the lagoon behind the cottage, which circulate, and, with the aid of overhead fans, keep the entire cottage cool. The furnishings, all selected by Delaine and Dick, look back to the casual polish of an expedition retreat: caned seats, canvas-sailed model ships, and pressed-back chairs. Wicker is mixed with rattan and casually slipcovered chaise lounges. Antiques grace every room with a seductive hint of travel and exploration.

This is a fair harbor, a glorious spot on earth where ever-cooling breezes create a paradise. Out back, a long walkway leads to a covered deck over the lagoon. Just slightly more restful than the cottage itself, the deck is its own sanctuary over the marsh grasses. The relaxed elegance of the property is evident in every detail found here.

Windows open to face a lagoon full of shrimp.

A screened porch provides space for afternoon and evening pleasures.
Three sets of French doors open into the living room. ▶

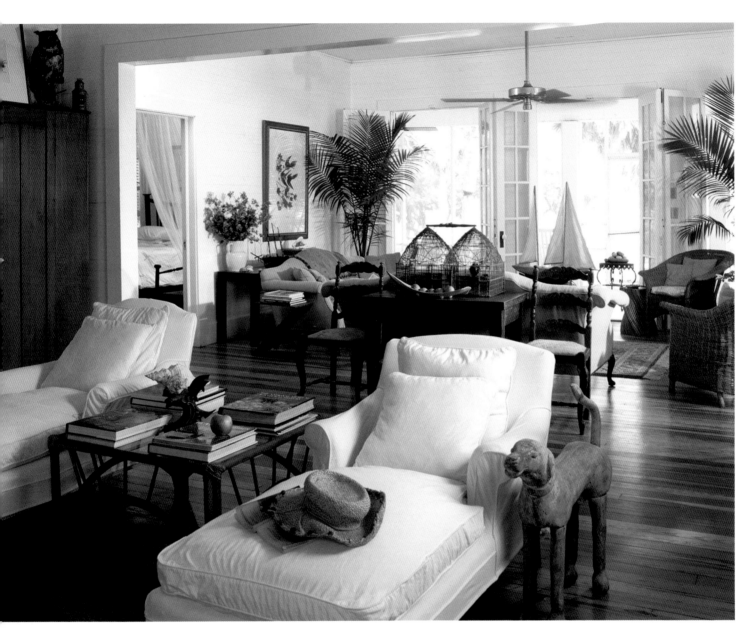

Perfect composition of furnishings invite guests to enjoy the cottage.
Painting of birds by Dick Henderson.

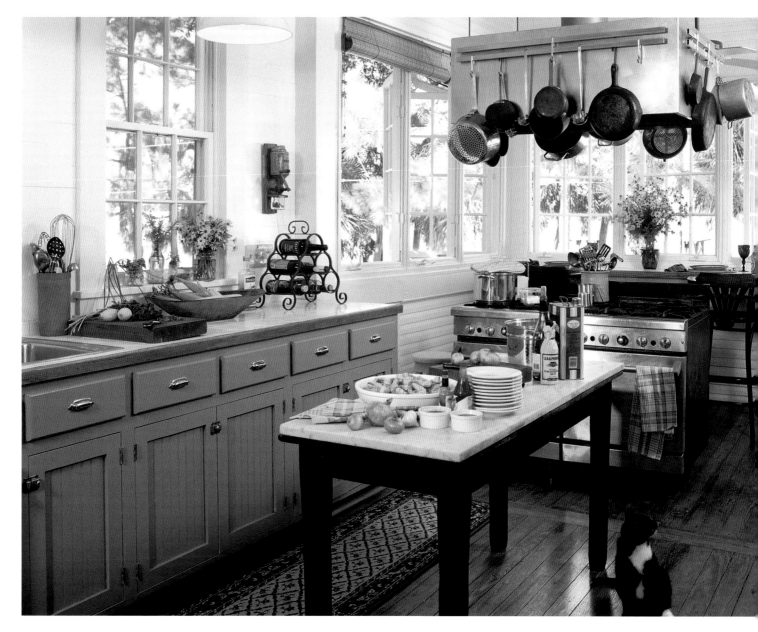

*The simple galley kitchen is created by the placement of
worktable and the use of stove as a room divider.*

The living room fireplace mantel is framed by sets of French doors.

The dining room features a small bar.
Trophy fish were gifts from the Henderson's children.

The kitchen pantry is stocked with cottage essentials.

Antiques fill the cottage guest room.

conclusion

Private Island Cottage

OWNERS: Charles and Theresa Walters

ARCHITECT: Phil Kallsen,
Kallsen Strouse Ishihara Architecture & Planning,
Seattle, Washington

PHOTOGRAPHER: Michael Mathers

Living on a ten-acre island can slowly reverse one's priorities. Charlie Walters grew up on Vashon Island, a small island in southern Puget Sound, with his childhood friend, Phil Kallsen. It wasn't a remote island—it is well within view of the nearby towns—but as boys, Charlie and Phil learned a few secrets about island living. Even today, Charlie lives in a small harbor town just across the Narrows from his childhood island home, where there are still eagles overhead, oysters in the shallow tide, and salmon in the bay. He is a lover of the sea and has been his entire life.

Things changed for Charlie when he and his wife sailed with friends in British Columbia in the eighties. Sailing where the wind took them and catching their meals, they spent days among the small islands and began to dream. In his unfinished island manuscript, Charlie writes, "One island . . . charmed us, with its hand-hewn float house and intimate sheltered coves . . . we never knew its name, and could not forget its charm."

Lives, fantasies, disappointments, and resurrections intervened, but with a whim of steel and a few lucky breaks, Charlie managed to snare that same seductive island whose

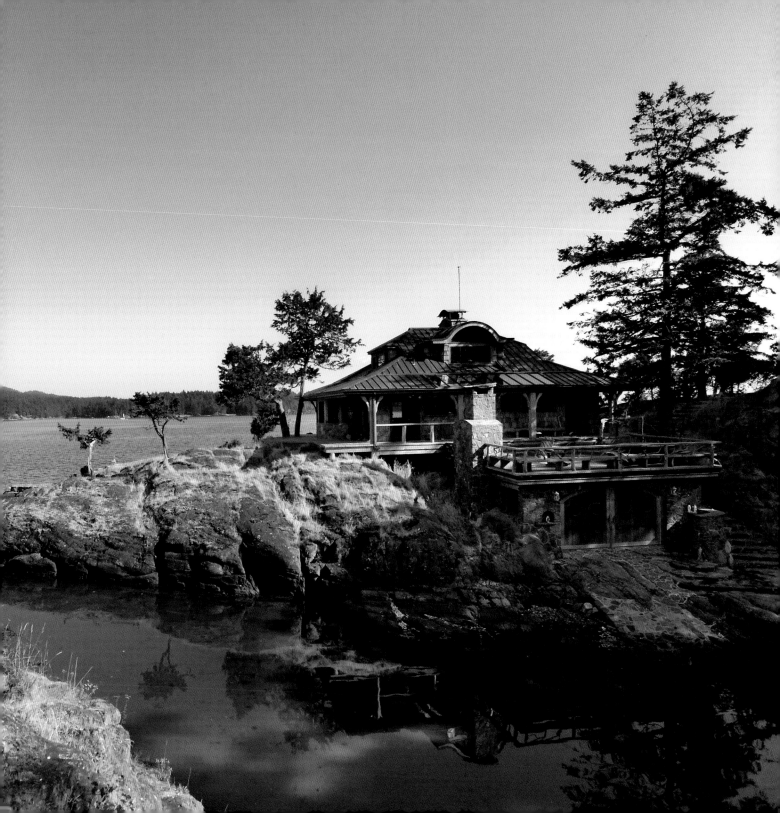

The owners sailed past this island in the late 1980s, and couldn't forget it.

Island living couldn't be better.

destiny it was to insinuate itself into their lives. Fifteen years after the last time they had seen the island and a full year after they'd bought it, they arrived at its shore.

From Charlie's manuscript:

> I stood in our boat and let my eyes roam over the rocky shores, in and out of the woods above them, and into the clear depths around us . . . as the water and trees cleared my thinking, in a manner that only wild things can do . . . our small island took hold of us. I had lived on the waters of Puget Sound most of my life, but now I saw how tame the south sound was. I had spent my time with friends who skied and wind surfed and climbed mountains. Now their daring seemed strangely civilized, as I wondered what type of folks we'd find living in this remote place.

Charlie, Theresa, and their three boys stayed in the old float house on the island during their summers. They learned about the ruggedness of this wilder place. Ahead lay many new life lessons about how to prosper and even survive on a remote island; most of the lessons having to do with that massive body of water around them that sets down its own rules and can very quickly accelerate foul weather and dangerous seas. Over the first few years, Charlie and his old friend Phil, now an accomplished architect living in Seattle, learned new lessons about this island life and began to design the island cottage. Plans were meticulous; the structure would be off the grid and sturdy—built on solid rock. This was just the beginning.

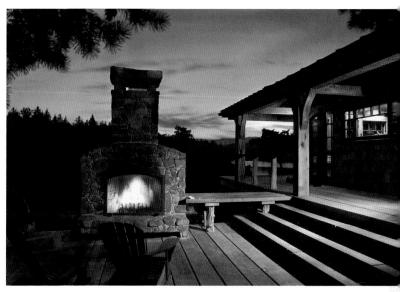

Friends paddle and motor among islands for parties consisting of everyone's catch of the day. Evenings are warmed by a large outdoor fireplace.

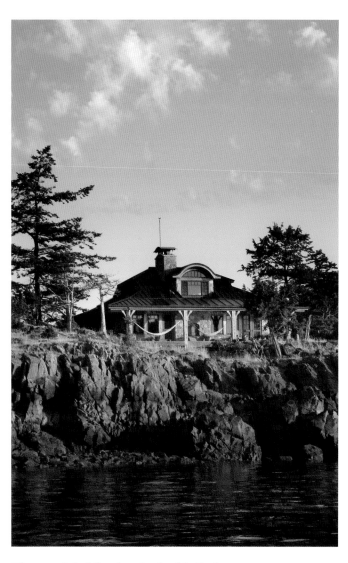

The cottage sits back from the rocky edge of the island.
Time spent in the many hammocks on the island is cherished.

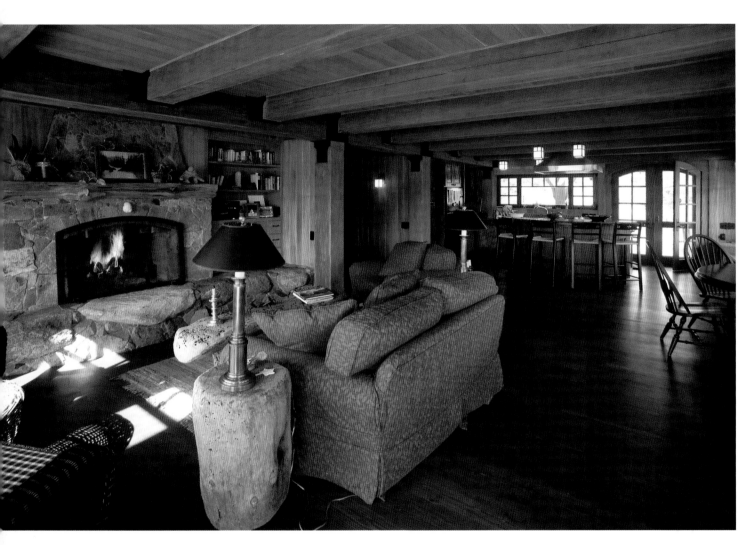

*Cottage interior reveals the strength and the bracing of the structure,
built to withstand fierce storm winds.*

Natural wood and found driftwood are
used throughout the cottage. Bronze fish
are inlaid into stairs.

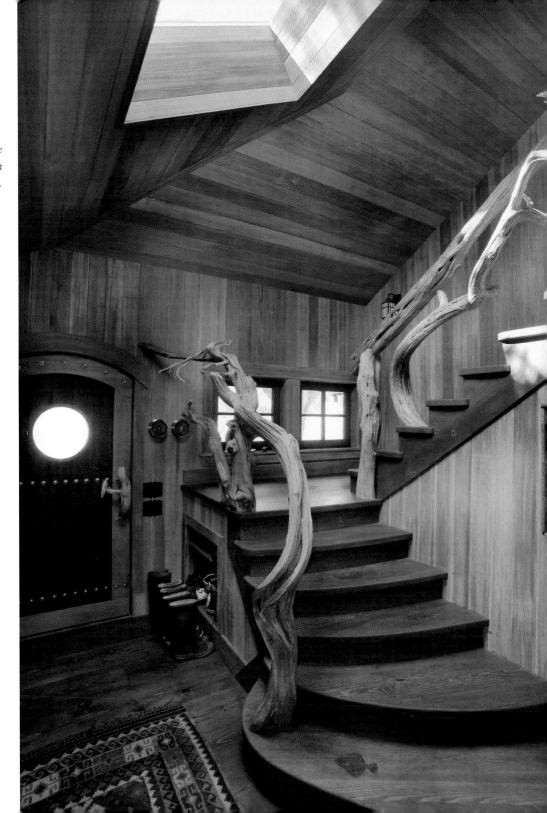

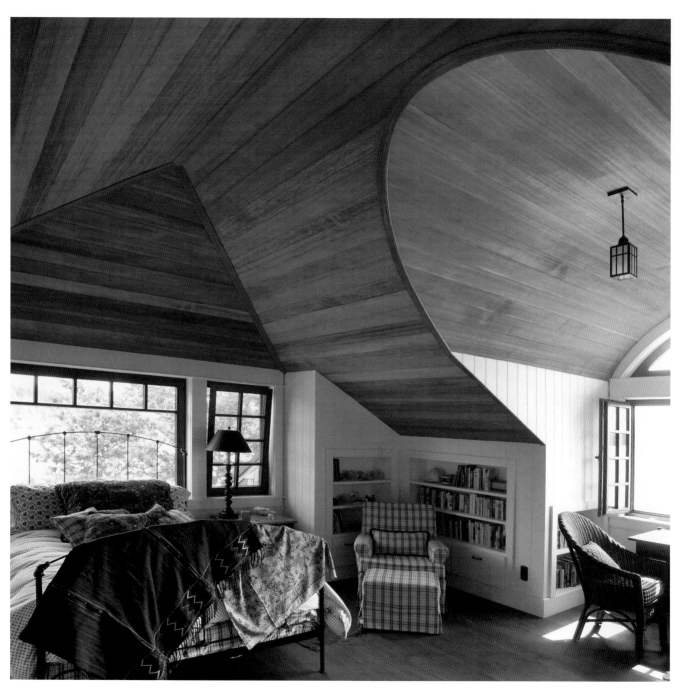

Dormers and gables intersect ceiling planes to create intriguing vaulted and shaped interior spaces.

The bath benefits from the arched window and ceiling. Side windows open for fresh marine breezes.

The fireplace with modest mantel of driftwood — the surround is of salmon in cast bronze.

Acknowledgments

THE JOYS OF THE BEACH are immeasurable: Ideas, thoughts, and plans that don't quite come together in the city, mountains, or desert, fall easily and silently into place here along the shore. It is where every seventh wave carries a hush of poetry—perhaps Merwin, Joyce, Pound, or Eliot. This is where the Sublimes merge, where Burke and Kant meet to overwhelm the senses and the intellect—where the only choice one can make is to make none.

I want to express my appreciation to those who work for the conservation and preservation of historic seaside cottages. I'm grateful to those who recognize that these cottages are a meaningful and integral part of our present and that the sites on which they are built will never become more valuable, aesthetically or economically, simply because a larger structure could be built upon them.

Enid Thompson Sales, Historic Preservationist and Founder of the Carmel Preservation Foundation is a tireless leader of cottage conservation and preservation in California. Enid provided valuable material from the Foundation's land use inventory of over 2,000 historic cottages in Carmel-by-the-Sea. She has my warm thanks. Claudine Van Vleet of the Carmel Preservation Foundation for her "beyond the call of duty" support of historic preservation. George W. Born, Historic Preservationist and Vice President of the Historic Florida Keys Foundation contributed his expertise and provided valuable information about historic Key West cottages. I also wish to thank Colin Chambers, Director of the Tybee Historical Society in obtaining information and images of the 1880's Tybee Island cottages.

I am indebted to Gloria Deison, an interior designer from Tallahassee, who contributed missives and suggestions from every corner of the country as she trekked and explored. Her tireless contributions were informative, entertaining, and enriching. To Dawn M. Fritz of Historical Concepts, LLC, in Atlanta, for her patience, composure, and sharing of many valuable resources, my thanks; to Jen Richardson at Photocraft in Portland, Oregon for her professionalism and humor in coordinating countless images, my gratitude.

My appreciation to the cottage owners for their participation in this book is immeasurable. Many shared their treasured, secret locations; others shared the chain of ownership of their cottage or their land. All have shared a reverence for the story that brought them to their cottage life. For architects who inspire and share their client's visions of life near the sea, the completed projects are themselves, their own best reward. The insight and humor of the architectural photographers fill the pages and to them, I am forever grateful.

I wish to thank senior editor Alex Tart for her steadfast guidance, patience, and support on this book. I wish her well while she is on leave, and look forward to her return. It is my good fortune to have had the opportunity to work with editor Holly Rothman, whose pert perspective and humor completed the project. To Charles Miers, Rizzoli/Universe's extraordinary publisher, thank you most sincerely.

And to Robert Paul, you little devil, you.

◄ *Bull kelp floating in the crystal waters of Puget Sound*

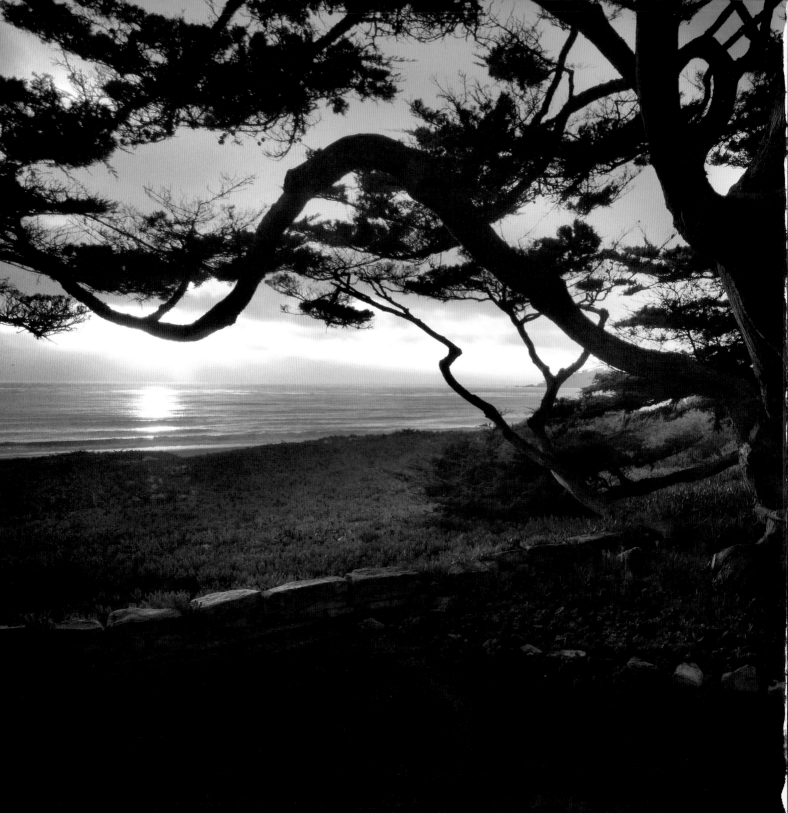